IMAGES
of America

MEXICAN CHICAGO

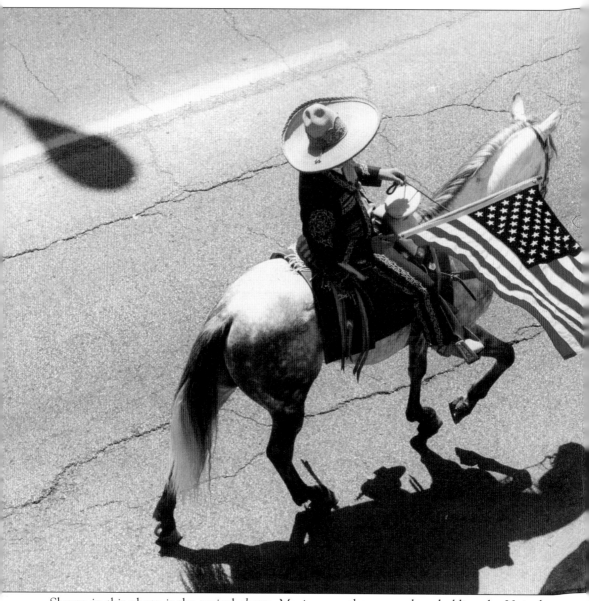

Shown in this photo is the typical *charro*, Mexican gentleman cowboy, holding the United States flag during a Cinco de Mayo Parade.

Cover Image: This photograph of Our Lady of Guadalupe's first communion class with Cordi Marian nuns and Claretian priests c. 1938 was taken with the communicants posed on the elaborate pre-Vatican II main altar with communion rail, candles, side altars, and the *estampa* of the Virgin of Guadalupe.

IMAGES
of America

MEXICAN
CHICAGO

Rita Arias Jirasek and Carlos Tortolero

Linda Xóchitl Tortolero López
Book Project Manager

ARCADIA

This book is dedicated to our families who were our first teachers, especially our late fathers Rodolfo P. Tortolero Jr. and Raymond C. Arias, with love and profound gratitude.

Published by Arcadia Publishing,
an imprint of Tempus Publishing, Inc.
3047 N. Lincoln Ave., Suite 410
Chicago, IL 60657

Printed in Great Britain.

Library of Congress Catalog Card Number: 2001088175

For all general information contact Arcadia Publishing at:
Telephone 843-853-2070
Fax 843-853-0044
E-Mail sales@arcadiapublishing.com

For customer service and orders:
Toll-Free 1-888-313-2665

Visit us on the internet at http://www.arcadiapublishing.com

CONTENTS

ACKNOWLEDGMENTS

The authors would like to thank our families, especially Arne Jirasek and María Felix Tortolero, for supporting us throughout the making of this project. Without your support, this book would not have been possible.

We would like to give a very special gracias to Antonio Pérez and ¡Exito! for the preparation and use of photos included in this book. Undoubtedly, Antonio has been the premiere photo chronicler of the beauty and achievement of Chicago's Mexican community over the past 20 years. We also would like to thank Miguel Zuno and his daughter Claudia Zuno, who have taken numerous beautiful photographs at functions throughout the Mexican community.

In addition, we would like to offer great heartfelt gracias to prominent individuals in our community who have been incredible contributors to this book, including: Carmen López Aquino, David Aragón, Carmen Arias, José Chapa, Jovita Durán, Olga and Mike García, Frances González, Alfred Jaques and Belen Jáquez, Carmen Mendoza, the Juan and María Ruíz family, Ignacio "Yance" Martínez, Virginia Martínez, Jorge and Luz María Prieto, Guadalupe Reyes, Faye Torres, Frank Valadez, and Arturo Velásquez Sr.

A special thank you to Dominic Pacyga, the book's unofficial "padrino" who challenged us to start this project. The help of the Mexican Fine Arts Center Museum's staff was also immensely important, especially our production assistant Karla Ornelas, Raquel Aguiñaga-Martínez, Rachel Blanco, Silvia Z. Cisneros, Joseph Delci, Juana Guzmán, Lydia Mendoza Huante, Maritza Luna, Cesáreo Moreno, Walter Ornelas, Eva Penar, Alicia Silva, Nancy Villafranca, and Angelina Villanueva.

Also, special thanks go to these institutions for letting us reprint photos, including: Chicago Historical Society and staff, Chicago Tribune, Southeast Historical Society, University of California Press, Pat Bakunas and the University of Illinois at Chicago.

Finally, we would like to acknowledge gratefully and thank kindly these following individuals and their families for their contributions: Jesús Alvarado, Alicia Amador, Calixto Arroyo, Henry Bais, Laura Barrón, Elvira Bautista, Aureliano Bermudez, Henry Bellagamba, John Campos, Román and Amelia Castañeda, Mario Castillo, Ray and Martin Castro, David and Marta Cerda, Julie Chávez, Gery Chico, Beatriz Rendón and Chicago Public Schools, CLASA, Carlos and Marianna Cortéz, Kathleen Culbert-Aguilar, Jennie Dianda, Father John Enright, Al Galván, Raúl González, Rica Gómez, Susie Gómez, Louis Guadarrama, John and Alice Heffernan, Lupe Hernández, Rodolfo Hernández, Sandra Hurtado, Coni and Marina López, Jon Lowenstein, Ray Marquez, Francisco Martínez, Martha Martínez, María Medina, Joe and Martha Mendiola, Gloria Mendiola, Adam Monreal, Ray Mota, Julia Muñoz, Scott Nava, Rosa Negrete, Adela Obregón, Francisco Ochoa, Danny Ontiveros, Arturo Pérez, Carol Pérez Segura, Raúl Ross Piñeda, Adriane Quintero, Marcos Raya, Henry Roa, Linda Robles, Father George Ruffolo, Natalie Ruíz, Francis Sarabia, Rod Sellers, Sonia Silva, María Luisa Sturgeon, Lewis Toby, Carmen Torres, Irene Toscano, Blanca Vargas Magaña, Wanda Victores, and Abundio Zaragoza.

PREFACE

With the publication of this book, we have taken the first step in creating a body of work that begins to document and preserve the history of Mexican communities in Chicago and to promote a more comprehensive understanding of the Mexican experience in the Midwest. A thorough investigation of mainstream libraries, museums, and universities made us realize that the history depicted by these photographs is not easily available to the general public. In addition—although there are increasing numbers of academic dissertations, articles, and books being written about us—few if any are told in first voice, our voice, the voices of those who lived and are living the history that these photographs document. We understand that this book has limitations—people, places, and events that could have been included, along with neighborhoods that are not completely represented. It is not our intention to exclude. This book is the first step in giving this rich history back to those who lived it, before many of these fragile, personal photographs disappear along with their owners.

The Mexican Fine Arts Center Museum has embraced this project, committing resources and linking it to permanent exhibitions at the museum. This book is meant to stimulate an ongoing dialogue about our history here in Chicago and the Midwest in general. There are large Mexican communities in Chicago suburbs and surrounding areas, towns like Joliet, Gary, Aurora, Elgin, Romeoville, and Cicero to name a few. Each of these merit their own future documentation.

We work as storytellers, presenting these images that bear witness to our presence and validate our contributions to the larger society. We invite readers to contact us about the book. Share your heirloom photographs, bring us your ideas for preserving and sharing these important links to our identity. As we enter the 21st century, with all of the promise it holds for our communities, please help us appreciate and honor our past, document the present, and create a legacy for the future.

INTRODUCTION

For more than 150 years, Mexicans have been part of Midwestern life. The earliest official mention of Mexicans dates back to the 1850 census, where 50 Mexicans were identified as living in Illinois. This early presence was probably limited to small family groups or individuals, such as the gentleman described in a letter mailed home from Chicago by José María Velasco, one of Mexico's most famous 19th-century painters. Señor Velasco served in a delegation of Mexican dignitaries given the charge of organizing the Mexican Pavilion at the Chicago Colombian Exposition of 1893. This letter, quoted in the work *José María Velasco: Landscapes of Light, Horizons of the Modern Era,* was sent home on May 14, 1893. Velasco wrote, ". . . yesterday morning we were at the Exhibition recruiting people. . . we went downtown to buy utensils to hang the paintings. . . when passing through these streets, we ran into a man who had a tin box with a white cloth in front of it that said 'Mexican tamales,' we got closer and asked him if he was Mexican and he answered that he was, I bought 10¢ worth of tamales which he sold to me at 1¢ a piece. . . ."

This letter documents a very early presence of Mexicans in Chicago. It puts forth a challenge to the widely held belief that Mexicans first began arriving in Chicago in 1916. Moreover, it raises questions about an overall lack of accurate verifiable information on the early immigration of Mexicans to the United States, and their migration patterns in the United States. It was only in 1820 that the U.S. government began to record immigration statistics and even then, the Immigration Bureau did not always track immigration by land from either Mexico or Canada.

The 1848 Treaty of Guadalupe Hidalgo ended the Mexican-American War and established a border on paper that was renegotiated with the Gadsden Purchase of 1853. This final change in territorial status resulted in the Mexicans of the region having their lands annexed by the United States. It also resulted in changes in their citizenship status, since residents of these lands who chose to stay in the new United States territories became American citizens. The resulting border not only divided territory, it also served to divide families who had previously lived on two sides of the river. These families had been accustomed to crossing the river freely to visit relatives and friends on the other side. Up until 1911, only a few border guards, called the Mounted Watchman, patrolled a 2,000-mile border which could still be crossed easily in either direction. In many instances, Mexicans did not so much immigrate to a new country as cross an invisible border into what had once been Mexican territory. These geographic and historical realities make the Mexican immigration experience a unique one, shared only by Canadians who may have experienced similar shifts in their national borders. Due to these factors, *la frontera,* a border territory often referred to as its own country was created.

In conversations with his daughters and grandchildren, Don Lucio Martínez (1886–1979) recalled traveling on foot or by mule across that invisible border many times as he looked for work beginning at the age of 13 or 14. It wasn't until his marriage and the birth of his eldest daughter that his unofficial immigration became formalized. His wife and daughter arrived in Chicago in 1923. Don Lucio was often quoted as saying, "nobody leaves their home and country because they want to, circumstance forces one to leave to seek a better life for themselves and their families." His words ring true even today.

One

THE ROAD TO CHICAGO

Mexicans who arrived in the industrial heartland of Chicago and Northwestern Indiana in the early 1900s immigrated from Mexico, and also migrated from other parts of the United States. Some of those who arrived in Chicago came looking for economic opportunity, some came to escape the uncertainties of the revolution, others to escape the religious persecution of the post-Mexican Revolution religious strife called the *Guerra Cristera*.

Railroads played a significant role in the movement of Mexicans in both countries. Not surprisingly, their labor played a critical part in the building and maintenance of those railroads. During the 1880s and '90s, the construction of North-American-owned railroads in Mexico with links to the United States and the expansion of Mexican-owned railroads to the border provided transportation for workers and a path to follow to *el norte*. It also allowed labor contractors to enter Mexico in violation of the 1885 contract labor law to search for workers. By the early 1900s, many Mexicans worked on *el traque*, which they called railroad work. "The first time my father left home he was 13 or 14 years old. He and several young men walked over 300 miles to reach the capital of Zacatecas where the train coming from Mexico City would stop. . . the men would walk on the track ties or hop railroad cars until they reached Laredo, Texas or Los Angeles, California," remembered Olga García.

Mexican workers and their families were employed as agricultural workers in states throughout the Southwest, but it was the sugar beet industry along with the railroads that helped establish the early Mexican communities in the Midwest. The *betabeleros*, sugar beet workers, and their families were usually recruited by beet company representatives. Labor contractors were called *enganchistas*, literally "the ones who hook you." These contractors were often paid fees for the workers they provided and also received a percentage of the wages that the workers earned, especially when they themselves worked as labor supervisors in the fields. Sometimes the contractor withheld a percent of the wages to guarantee that the worker would work until the end of the harvest. Other fees might also be deducted from the workers' wages for transportation and food provided by the contractor. The workers often found themselves being shipped in railroad cars, which doubled as housing, to the beet fields of Michigan, Ohio, Minnesota, Nebraska, Iowa, and the Dakotas. According to the Bureau of Labor Statistics, from 75–90 percent of the beet workers in these states were Mexicans, with similar percentages of Mexicans involved in beet production in Colorado and other Rocky Mountain states. The Dingley Tariff Act of 1897, which put high taxes on foreign sugar, along with the American demand for sugar required an ever-growing labor pool. Once the workers made it to the Midwest, it was not uncommon for them to travel to Midwestern cities like Omaha, Gary, and Chicago looking for work that was better paid and less arduous than the $2 per 10-hour workday in the fields.

Life for the migrants was very difficult. The work in the fields with the *cortito,* as the short hoe was called, was backbreaking. Housing was rarely as had been promised by the recruiters, and child labor was common.

These photographs create a visual record of some of the places where Mexicans worked and lived on their journey to Chicago. Most of them who crossed the border officially entered the United States at border crossings in El Paso, Eagle Pass, or Laredo, Texas. During this time period and even up until the 1930s, few of them came directly from the border to Chicago. Their routes were as amazingly varied as were the jobs that they did on the way. Their work included agricultural work, mining, railroad work, factory and foundry work, as well as many other unskilled and semiskilled occupations. According to Carmen Mendoza, "My family left Mexico in about 1914. When they got to the border they had to pay 5¢ per person. My grandmother's husband, my step grandfather, got a job on the railroad. Men who worked on the railroad could travel further by repairing and laying track. He worked for the EJ&P (Elgin Joliet and Pacific). Railroad cars were made into trailers so families could live in boxcars and likewise travel. Families traveled state to state by laying and repairing track. My grandmother used to cook and sell food to the *hombres solos* (single men) and take in washing. My mother and my aunt helped her. It took them five years to arrive in Argo Summit (outside Chicago)."

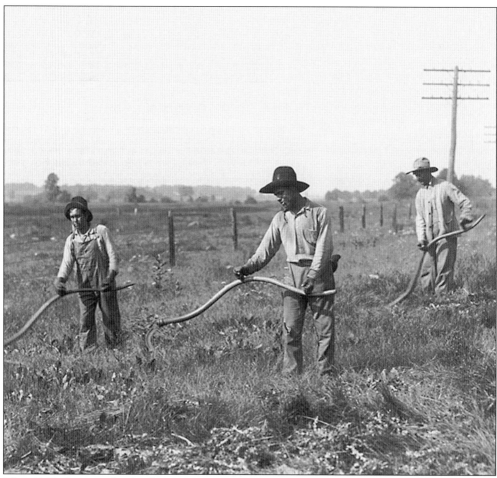

This 1917 photograph of unknown Mexican workers taken in Willow Springs, Illinois, shows them working with scythes. (Photo courtesy of Chicago Historical Society.)

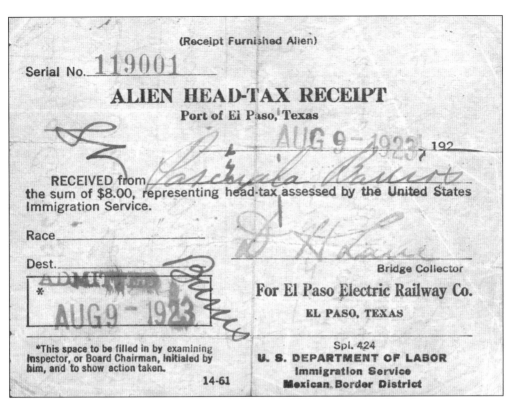

(Receipt Furnished Alien)

Serial No. 119001

ALIEN HEAD-TAX RECEIPT
Port of El Paso, Texas

AUG 9 - 1923, 192___

RECEIVED from _Pascuala Pruata_
the sum of $8.00, representing head-tax assessed by the United States
Immigration Service.

Race_____

Dest._____

ADMIT
AUG 9 - 1923

* _____
Bridge Collector

For El Paso Electric Railway Co.
EL PASO, TEXAS

*This space to be filled in by examining
Inspector, or Board Chairman, initialed by
him, and to show action taken.

14-61

Spl. 424
U. S. DEPARTMENT OF LABOR
Immigration Service
Mexican Border District

By 1923, when this receipt was issued, the head tax upon entry was $8. Earlier fees had been as little as 5¢. Stamps on the back of the document mark re-entries in 1925 and again in 1941. Carmen Martínez, the two-year-old child named on the back of this document, traveled on her mother's papers. Although she never returned to Mexico to live permanently, she did not go through formal citizenship proceedings until 1957. When interviewed about that experience, she remembered, "the judge did not even make me take any citizenship tests when he looked at my entry document and after I showed him my elementary and high school diplomas. He swore me in on the spot."

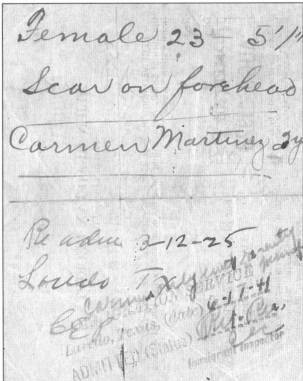

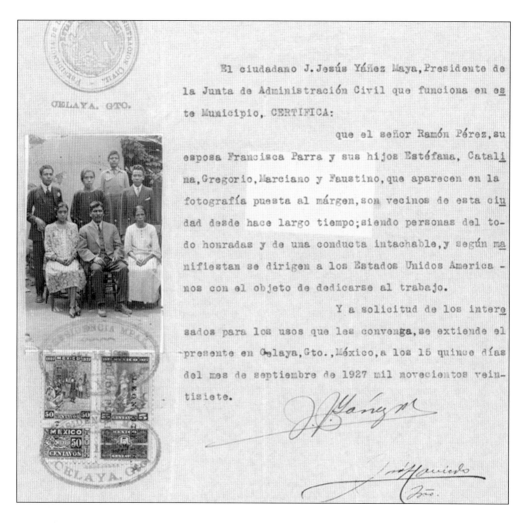

El ciudadano J.Jesús Yáñez Maya,Presidente de la Junta de Administración Civil que funciona en este Municipio, CERTIFICA:

que el señor Ramón Pérez,su esposa Francisca Parra y sus hijos Estéfana, Catalina,Gregorio,Marciano y Faustino,que aparecen en la fotografía puesta al márgen,son vecinos de esta ciudad desde hace largo tiempo;siendo personas del todo honradas y de una conducta intachable,y según manifiestan se dirigen a los Estados Unidos Americanos con el objeto de dedicarse al trabajo.

Y a solicitud de los interesados para los usos que les convenga,se extiende el presente en Celaya,Gto.,México,a los 15 quince días del mes de septiembre de 1927 mil novecientos veintisiete.

This document, dated September 15, 1927, is an affidavit from the Municipal President of Celaya, Guanajuato. It certifies that Ramon Pérez, his wife Francisca Parra, and Estéfana, Catalina, Gregorio, Marciano, and Faustino, who appear in the document's photograph, are longtime honorable residents of the town. It adds that they have declared that they are going to the United States in search of work.

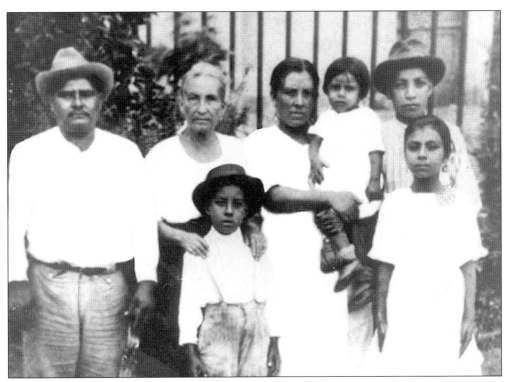

This photograph of Rodolfo Salmerón and his family was taken in Mexico and was used as a family passport photograph. Unlike most families who migrated from the central plateau states, this family was originally from the far southern tip of Mexico, Tehuantepec, Oaxaca. The Salmerón family worked in sugar beet fields in Michigan. They settled in Chicago in 1923, and lived at 830 West Taylor Street. At the age of 60, Rodolfo received a college degree and worked for the Chicago Public Schools. In the 1970s, his son, also named Rodolfo, became the first Mexican to assume a position as District Superintendent for the Chicago Public Schools.

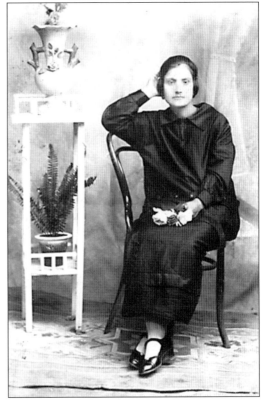

This 1916 photograph of Bentura Villalpando in Jalisco, Mexico, was taken shortly after her marriage. It was mailed to her husband, who had gone to the United States to work. The inscription reads, "Remembrance for my husband, yours Bentura Villalpando."

13

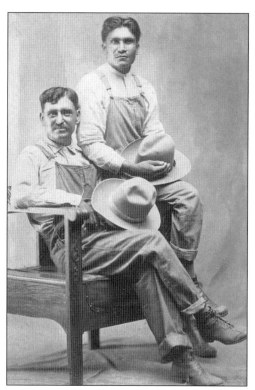

Pictured are two unidentified workers in McCook, Nebraska, c. 1920. They appear to be *solos*, or young men who migrated without family.

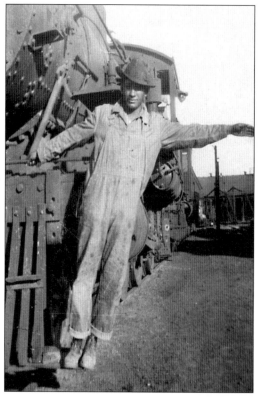

Phil Ocasta, a railroad worker pictured here c. 1925 in Nebraska, lived in camp cars alongside the sugar beet workers.

Pictured are *betabeleras*, female sugar beet workers, including Frances Martínez, center, with cut sugar beets. This photograph, taken *c.* 1926, along with the certificate of merit issued by the Great Western Sugar Company documents that entire families worked in fields much like the migrant families of today.

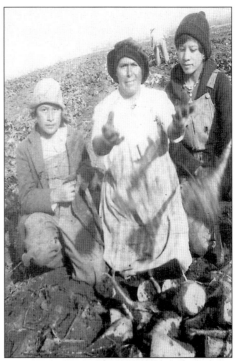

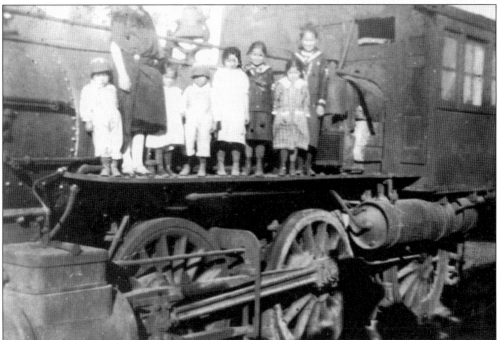

The Martínez children with friends are photographed here on a locomotive in McCook, Nebraska. The Martínez family arrived in Nebraska in 1916 from Aguascalientes, Mexico. Yance Martínez stated "I remember my parents telling me that they were loaded on trains. They didn't even really know where they were going. They lived in railroad cars along side of the fields, I was born in one of those cars."

CERTIFICATE OF MERIT 1927

ISSUED BY

SERIAL No. 5105 A

THE GREAT WESTERN SUGAR COMPANY

To *M. Martinez* His Signature

Age *29* Yrs. Height *5'3"* Weight *137* No. in Family *3*

Thinned *20.5* A. Hoed *20.5* A. Weeded *20.5* A. Topped *20.5* A.

For *O.C. Brown* Grower At *Perry* Station

Quality of Work *7* Class

Signed *L. R. Mondt.* Fieldman

Postal Address *Culbertson, Nebraska.*

Certificate of Merit: Great Western Sugar Company Document, is pictured above. At the time this certificate was issued, M. Martínez was 29 years old. The certificate was issued for excellent work thinning, hoeing, weeding, and topping 20.5 acres at Perry station.

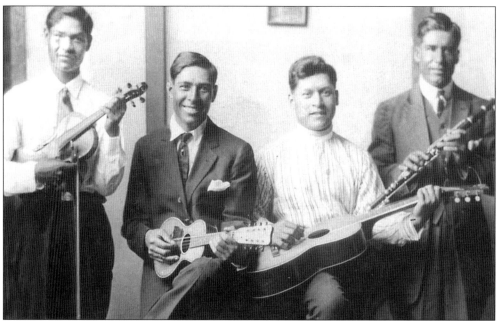

Teofilo Martínez and his band in McCook, Nebraska, are seen in this *c.* 1925 photograph. An important component of the Mexican experience in the United States, music was a natural way for Mexicans to preserve their culture and memories of home. Groups like these played a wide range of music, including *corridos*, or folk ballads, that told of the hard life of *los enganchados* in song.

This photograph, taken at Notre Dame in South Bend, Indiana, in 1927, includes Arturo Velásquez Sr., pictured at right. He was part of the Minims Program, where grade-school-age students were enrolled and boarded at St. Edwards Hall. "A priest sent me to Notre Dame, I studied there for a year," remembered Arturo Velásquez. "As a kid, I worked picking sugarbeets in South Dakota and tomatoes in Iowa. I went to thirteen different grammar schools." Sr. Velásquez would later become the patriarch of Chicago's most distinguished Mexican family.

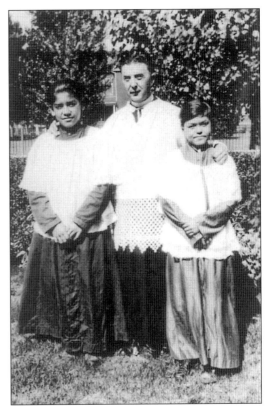

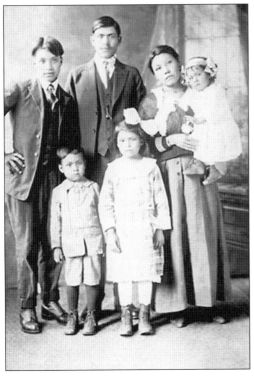

This family photograph of the Torres and Gómez families was taken in 1921, in Saginaw, Michigan. It includes Primitivo Gómez, Carmen Torres, and Aurora Gómez Torres. The children in the photograph are, from left to right: Angel Torres (known as Angle), Tomasita Gómez, and the child in arms is Santos Torres. The inscription on the reverse indicates that they were living in Pigeon, Michigan. They made their way to South Chicago around 1922.

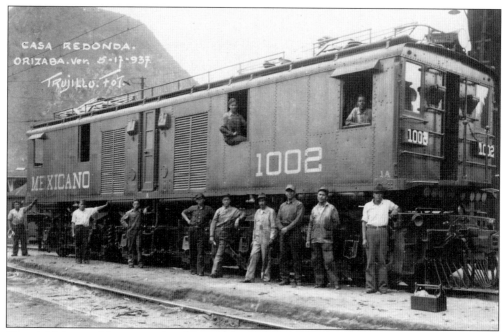

Pictured here is a Mexican railroad car sitting outside of the roundhouse in Orizaba, Veracruz, in 1937. All men depicted are railroad workers, similar to other railroad workers who made the journey via rail all the way to Chicago.

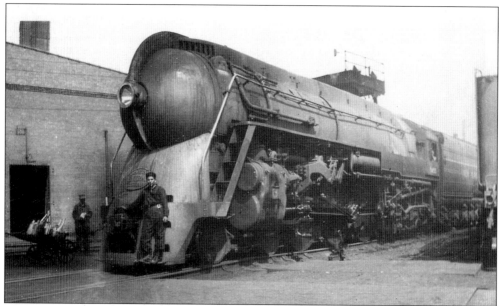

Pictured here in 1944, Calixto Arroyo is standing on one of the New York Central Railroad's biggest engines—the Streamlined Hudson. Calixto was first contracted as a bracero for the agricultural field of California after migrating from Tendeparacua, Michoacan. Later that year he was contracted by the New York Central Railroad to work in the round house. He lived in a boxcar facility in Cleveland, Ohio until 1945. Calixto eventually made his way to South Chicago, and later arranged for his family to emigrate in 1957.

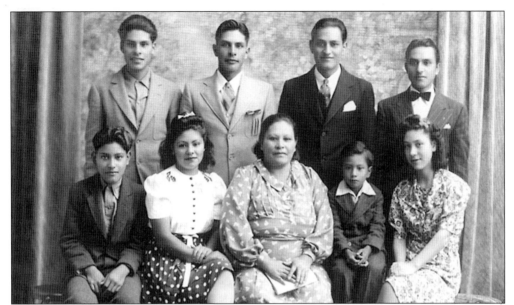

The Cesáreo Moreno family, photographed here in North Dakota, originally migrated from Irapuato, Guanajuato, to Texas. They worked in *la labor,* as the fields were called throughout Texas, arriving in the North Dakota Red River Valley close to the Minnesota border in 1930. A short time after their arrival, Cesáreo, the father, died. The family stayed and continued to live and work until the first of the brothers was drafted in 1941. Three other brothers were also drafted. The combination of the brothers leaving and the recent death of the family matriarch in 1942 provided the opportunity for the remaining members of the family to "pack up the Chevy Special Deluxe and move to Chicago," according to grandson Cesáreo Moreno. They stayed with a family friend, Rosendo Santos, near Harrison and Laflin. With the return of the four brothers from service, the family never returned to *la vida del campo* and remained in Chicago.

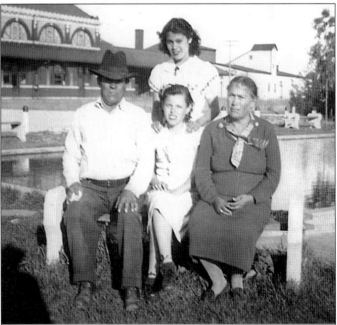

Railroad worker Juan Vásquez is photographed here with his wife, Romal de Vásquez, and his daughters, Ernestina and Estela. Taken in the 1930s, they are shown in front of a railway station somewhere in one of the Great Plain states. Mr. Vásquez worked laying track.

The woman in this photograph, Clemencia Martínez Rodríguez, was born in San Antonio, Texas, in 1890. She married Isidro Rodríguez, had four children, and divorced. In about 1920, she and her two young daughters, Josefina and Juanita, made an incredibly difficult journey from Waco, Texas, to Chicago by walking and hitchhiking. They took shelter wherever they could, often sleeping in barns. "My mother, Juanita, rarely spoke about this time. When I was a little girl, I never understood why my mother was always so hurt that I didn't like dolls. It wasn't until many years later that she told me that on that long walk from Texas to Chicago, she traded her favorite doll to a kindly farmer's wife for a pair of shoes," shared her daughter Virginia Martínez. After arriving in Chicago, Clemencia found that she was unable to support her daughters, and put them in an orphanage in Indiana. She worked as a cook in a restaurant. She lived at 225 West 25th Street from the early 1940s until her death in 1958.

Resident Alien Crossing card, pictured here, belonged to Mr. Manuel Martínez Tovar. Mr. Martínez first came to the United States at about age 14. He worked for the railroads in the Southwest and eventually arrived in Chicago around 1925. In 1935, he married Juanita Rodríguez. During their marriage he and his family returned to Mexico to live twice, but came back to Chicago. The Resident Alien's Border Crossing Identification card shown here identifies Mr. Martínez as a resident of Chicago, living on West 25th Street. The Martínez family had earlier lived at 18th and Des Plaines. The construction of the Dan Ryan Expressway displaced the family once again, and they moved to 19th and Throop.

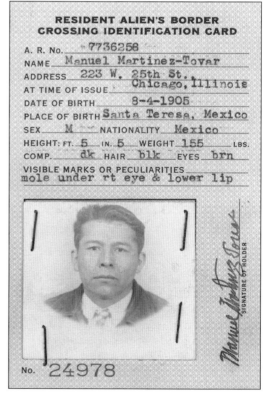

RESIDENT ALIEN'S BORDER CROSSING IDENTIFICATION CARD

A. R. No. 7736258
NAME Manuel Martinez-Tovar
ADDRESS 223 W. 25th St.
AT TIME OF ISSUE Chicago, Illinois
DATE OF BIRTH 8-4-1905
PLACE OF BIRTH Santa Teresa, Mexico
SEX M NATIONALITY Mexico
HEIGHT: FT. 5 IN. 5 WEIGHT 155 LBS.
COMP. dk HAIR blk EYES brn
VISIBLE MARKS OR PECULIARITIES
mole under rt eye & lower lip

No. 24978

Two
FAMILY

Without families, neighborhoods are just a collection of houses. A city map can outline neighborhoods, but the people that live in them are what give neighborhoods a heartbeat and flavor. The borders of these neighborhoods, like borders between countries, are impermanent lines on paper drawn by government officials and city planners. The families photographed here shaped the neighborhoods they live in, inventing or redefining them as they filled them with reflections of their culture. The Mexicans who came to Chicago brought with them the notion of permeable borders, and they negotiated a different reality about them. These borders—whether they were international, state, city, or neighborhood boundaries— were and perhaps continue to be, political abstractions to these families who crossed them. The stories and photographs of these families that made up the early *colonias* suggest that they maintained elaborate networks across these borders and in doing so preserved cultural and family ties.

The experiences of these early families were different from the experiences of the Mexicans who immigrated but remained in the Southwest. Chicago communities existed in an urban environment in territory that held no historic baggage. Diverse employment opportunities were, for the most part, less affected by seasonal layoffs as in agriculture. Wages were somewhat higher too. Moreover, the growth of the Mexican *colonias* in Chicago reflected the importation of Mexican labor for specific industries, namely railroads and steel. These families were much further away from Mexico, making it harder for them to come and go. Children entered an urban school system with other ethnic immigrants where great emphasis was placed on "Americanization" and assimilation. They also became involved in settlement houses that fostered American social and cultural values. Chicago was and continues to be an ethnically and racially diverse city, where despite racial and ethnic tensions, Mexican neighborhoods endured.

The photographs gathered here represent a fraction of the family photographs that document the presence of Mexican families in many Chicago neighborhoods. Most of the families in these early photographs stayed in Chicago, proudly contributing to all aspects of community, cultural, and work life. Immigration from Mexico did not stop. New families continued to arrive to traditional ethnic Mexican neighborhoods, searching for the same economic opportunities that brought earlier immigrants.

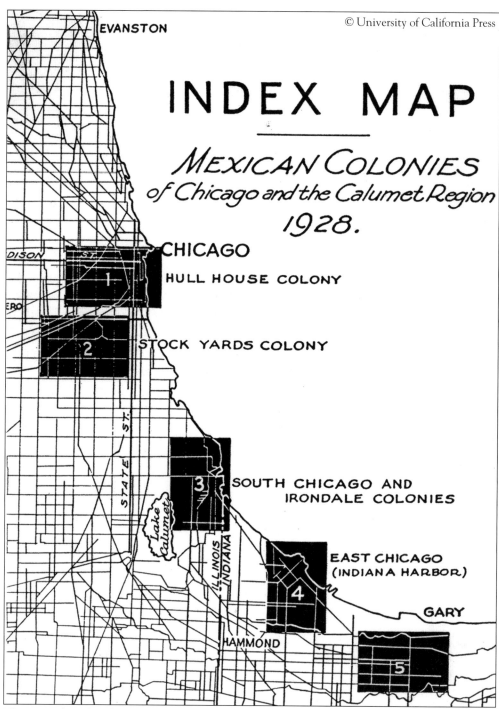

INDEX MAP

MEXICAN COLONIES
of Chicago and the Calumet Region
1928.

CHICAGO

HULL HOUSE COLONY

STOCK YARDS COLONY

SOUTH CHICAGO AND
IRONDALE COLONIES

EAST CHICAGO
(INDIANA HARBOR)

GARY

HAMMOND

EVANSTON

This map identifies the Mexican colonies as they existed in 1927. It is taken from Paul Taylor's seminal study on Mexican Labor in the United States. His work, done at the University of Chicago, fits into the Chicago School of Sociology work done by Paul Redfield, Anita Jones, and others. Much of this important work is not available to the non-academic researcher, as it is archived in special collections here in Chicago and in California.

22

Interviewed in 2000, Susie Gómez spoke of her early life on the West Side of the city. This photograph was taken in 1921, somewhere on Halsted Street at the time of her baptism. She is being held by her godfather, Severo Benites, who took vows for her during the religious ceremony. The godparent-parent relationship established by this act is called *compadrazgo*. This is, in the most traditional sense, a very formal co-parenting relationship. It is integral to the Mexican network of families and extended family relationships both in Mexico and the United States. The *madrina* (godmother) and the *padrino* (godfather) vow to be responsible for the spiritual, and sometimes material, well being of the godchild. The *compadres* (godparents) were often called upon to raise their *ahijados*, (godchildren) when family circumstances required it. As such, being chosen a *compadre* or *comadre* represents the faith that the parents of the child have in the spiritual and personal values of those that they choose to be godparents. It is considered a great honor to enter into this relationship.

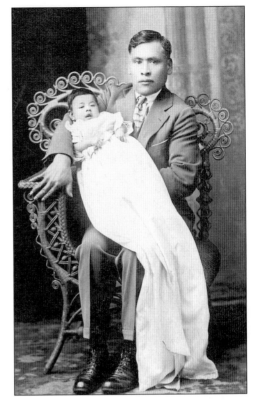

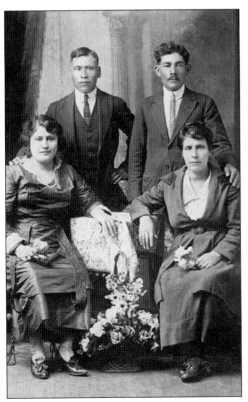

This photograph of the *compadres*, parents and co-parents of Susie Gómez, illustrates the seriousness of this relationship. They are posed in a formal family portrait. Susie's early life was spent on the West Side of the city. Susie Gómez recalls, "When my father first came, he was standing on the corner of Wabash and Harrison looking for Mexicans. He stopped the man who would become my godfather, Benites, who helped him. They lived at 1130 South Halsted on the second floor of a building that was torn down." Susie took part in activities both at Hull House and Marcy Center. She is a respected community elder.

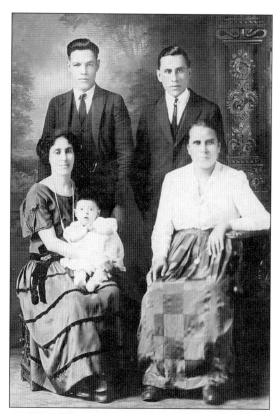

This photograph, taken in South Chicago, is also a photograph of *compadres*. Mr. and Mrs. Felipe Casteñeda are shown here with Mr. Manuel Pérez and his mother, Mrs. Emilia Pérez. Mr. Pérez's future son, Manuel Pérez Jr., was posthumously awarded the Congressional Medal of Honor for his heroic actions during World War II (see page 83).

Don Dorotéo Ruíz and family are shown in 1926. This is one of the first Mexican families to settle in South Deering, also known as Irondale. Don Dorotéo registered for World War I while living in Texas. Several of his sons served in World War II. His daughter Natalie remembered, "My dad was in a pool hall on Easter Sunday when a recruiter walked in and said that he needed two workers. My dad volunteered, and that is how we ended up in Chicago."

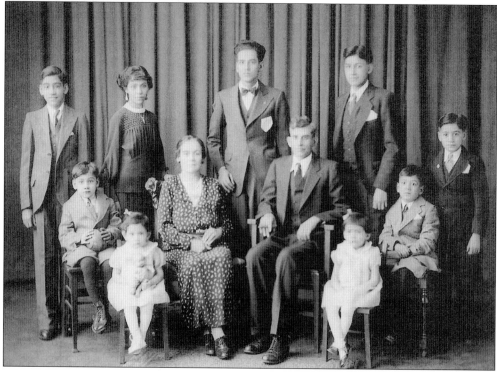

Marciano Macías is photographed here during the late 1930s, at the Fratelli Cannata—an Italian photography studio on Halsted Street. Mr. Macías was born in Los Pitos, Guanajuato, in 1888. He left Mexico in 1927 to work for the railroad in *el norte*, and worked in such places as Chicago, St. Louis, Detroit, and Indiana. He was one of many Mexicans who moved into the Italian neighborhood in the area that is now dominated by the University of Illinois. After working for several years, he returned to Mexico. He worked for the Municipal Presidency, and was forced by rebels to participate in an insurrection against the Mexican government. After being pardoned by the Mexican government, he eventually returned to Ocampo, and lived there until his death at the age of 55.

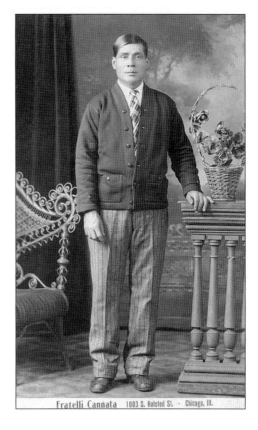

Fratelli Cannata 1003 S. Halsted St. · Chicago, Ill.

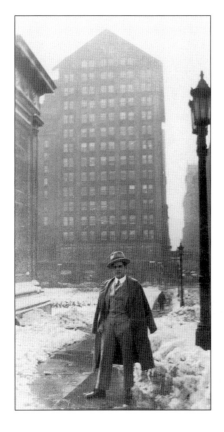

This photograph was taken of Juan Ruíz on Michigan Avenue in the late 1920s. Mr. Ruíz and his family were very early residents of South Chicago. He was a businessman and community leader.

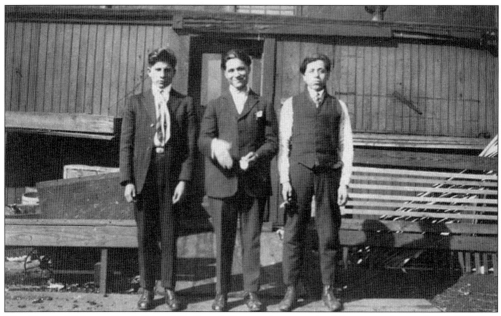

The South Chicago Rock Island Railroad Camp photographed here was located at 2650 East 95th Street. The converted boxcars were called camp cars. Introduced in Chicago as early as 1917, railroad camps provided housing to many workers. Anita Jones, in her 1927 dissertation *Conditions Surrounding Mexicans in Chicago*, listed 22 different camps. The well-dressed men featured in this photograph worked for the railroad and lived in these cars with their families. They are members of the Torres family that was shown photographed earlier in Saginaw, Michigan.

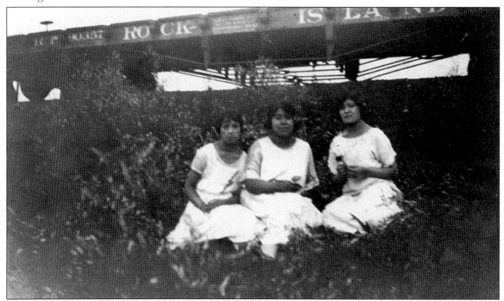

These three young women are posing in a field in front of a railroad car with the Rock Island logo. At one time there were as many as 15 camp cars at this site. "I remember visiting the box cars when I was a little girl," stated Carmen Arias, "I would help clean the kerosene lanterns that they used for light. There was no running water in the houses, and we used outhouses."

Shown leaving her camp car home in this photograph is Mary Torres. The camp cars varied greatly as did the amenities that the railroad company provided. Some cars provided enough space for the family to have two separate rooms. Some bachelors, or *solos,* lived as borders in family cars, others lived in single-men-only sections. There were seven different rail lines that provided worker housing in this way, in and around Chicago.

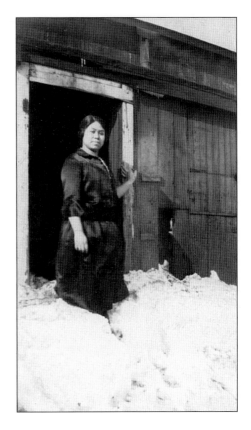

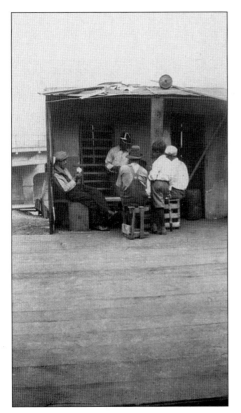

The men in this photograph are playing cards on a platform that was built for dancing on summer weekends. A recent public radio program featured interviews with Mexican railroad workers in Mexico City, who continue to live in railroad encampments such as these pictured here from the 1920s and '30s.

This photo of Bernardo Jáquez was taken in South Chicago. He worked in the mills and died at the age of 30 from tuberculosis—a disease that took its toll on many. He is standing in an alley off Brandon Avenue.

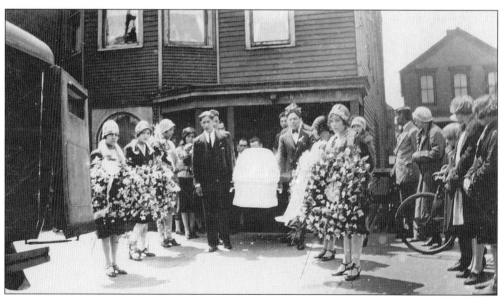

Wakes were traditionally held at home during the 1920s. Pictured here is the elaborate funeral of María Luisa Ramos Peralta, held in 1928 in South Chicago.

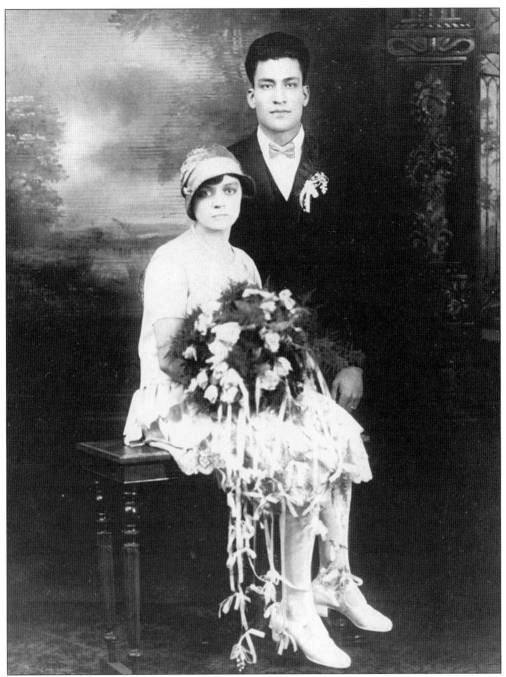

This wedding portrait is of Justino Cordero and his wife, Caroline Kon. They were married in the original frame mission church of Our Lady of Guadalupe in 1924. This is a portrait of an interethnic marriage. Caroline, although Polish by birth, completely embraced her husband's culture, learning its language and customs. She was one of many young non-Mexican women who married Mexican men, often in the face of much resistance from both families. Her husband Justino, who recently celebrated his 94th birthday, is a well known and highly respected business and community leader in South Chicago. (Photo courtesy of the Southeast Historical Society.)

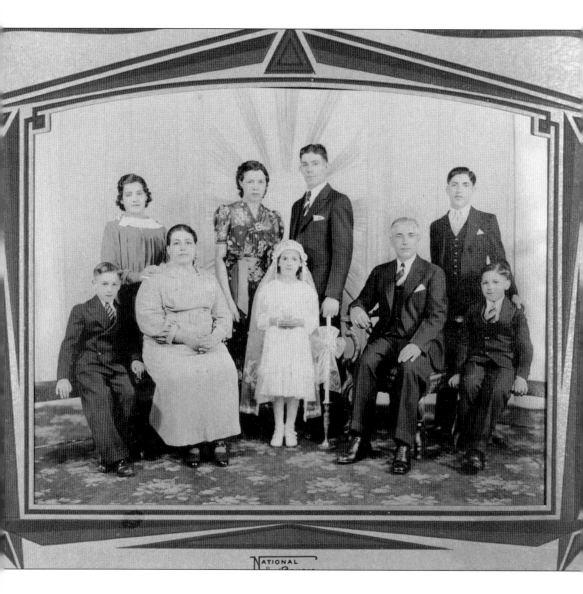

This first communion portrait of Carmen López and her family was taken c. 1930. First Communions were important family events. Carmen, like most female communicants, is wearing an elaborate communion dress and veil. Young men usually wore suits. The outfits were made at home or purchased especially for the occasion. After the ceremony, family parties were hosted at home, where traditional Mexican foods were served. Formal studio photographs taken at that time were usually sent to loved ones in Mexico and other parts of the United States as a remembrance of the occasion.

This 1939 photograph of Mary Lou Peralta and Alfred Jaques captures them in their first communion clothes.

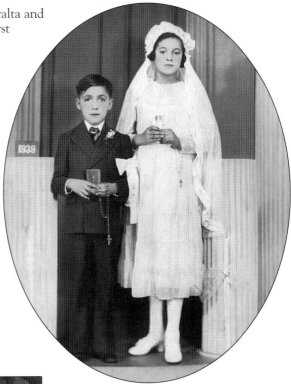

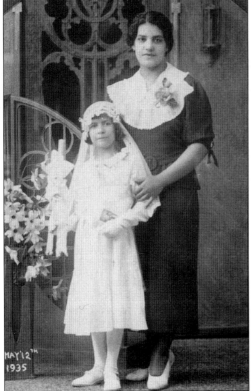

The inscription on this formal studio portrait reads in Spanish: Miss Carlota López and family, receive this as a remembrance from your goddaughter shown here, your compadres Carmen J. Mota, Chicago, IL.

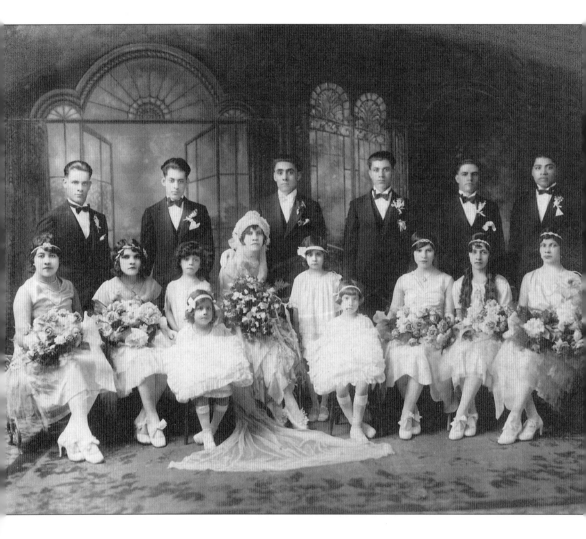

This elaborate wedding party was the wedding of Bernardo Jáquez and Maria López. They were married at Our Lady of Guadalupe Church in the late 1920s. The groom, third from the left, is also pictured at the top of page 28.

Shown in a portrait taken *c.* 1923 are
Margaret Bais and Salvador "Chino" Bais.
The children were born in Monmouth,
Illinois, but later moved to South Chicago.
Chino grew up to be quite an athlete and was
the only Mexican to play on the South All-
Star Team at Comisky Park in 1939. He was
also a Golden Gloves Champion in 1937.

The children shown in this photograph are
Henry Bais and his sister Josefina. The original
photograph was printed as a postcard and is dated
March 24, 1931. Eulalio Bais, the children's father,
was born in Irapuato, Guanajuato, in 1890. He
arrived as a *solo* and worked on the railroad. The
inscription gives the ages of the children as four and
one, and dedicates this as a remembrance for Mr. Simon
Mendiola M. and family.

Two young mothers, María Ruíz and Carmen Carrillo Mota, are pictured here in South Chicago *c.* 1931 with their children Elisa Mota and Luís Ruíz (seated).

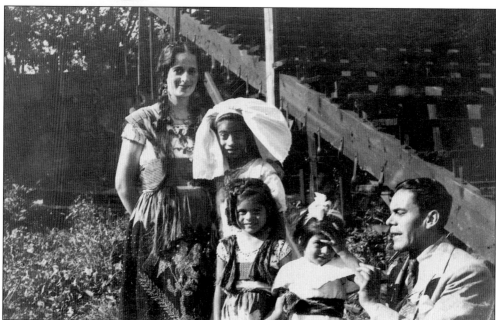

Family members in this informal photograph taken in 1938 are dressed in *traje regional,* regional dress. Maria Victoria, Beatrice, Celia, Carol, and Rafael Pérez, portrayed here from left to right, lived on the north side of the city. Rafaél was one of the first Spanish-language radio announcers in Chicago.

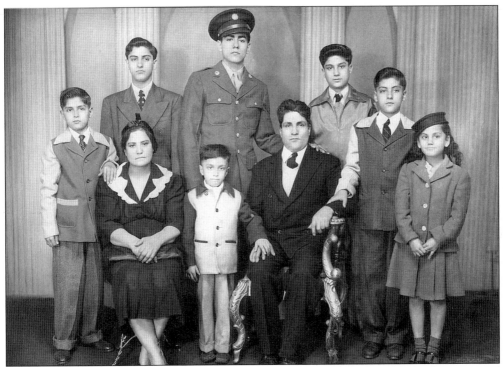

This Valadez family portrait, taken in 1944, shows Gerardo and Bentura Valadez (also pictured on page 13) with their children. The Valadez family were early arrivals to South Chicago from the Mexican state of Jalisco. They became very well known and respected labor and community leaders.

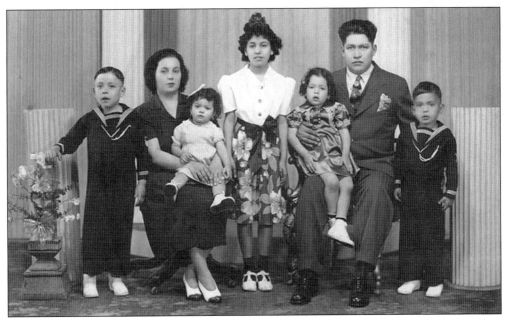

Shown in this 1941 family portrait are the Juan and Esperanza Medina family with their children, Margarita, Rogelio, Gilberto, Amelia, and Guadalupe.

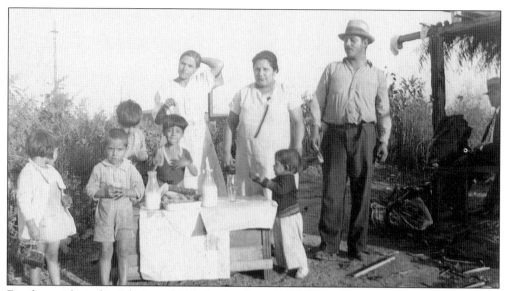

Families, such as the Salario and Valadez families, would often plant gardens on empty railroad land. This garden was called *Las Cuatro Milpas*, probably after a popular Mexican song with the same title. Produce raised in gardens like these supplemented family diets, especially during the Depression and the War years. Community gardens were also planted on other railroad land. In South Deering, the managers of Wisconsin Steel at one point sent tractors to plow railroad land along the tracks near 103rd Street. They then gave workers seed to plant. Many of the workers had done farm work either in Mexico or other parts of the United States. These men used all of their ingenuity and skill to raise vegetables. It was not uncommon for them to dig wells and take turns weeding, watering, and protecting the gardens when they were not working.

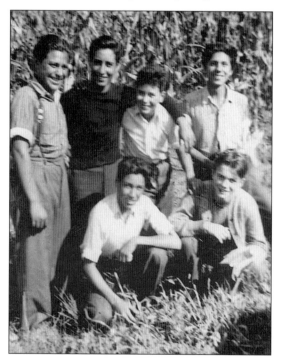

Pictured are friends getting together in *la milpa*. The gardens were quite extensive; corn, beans, squash, and other vegetables were planted. For men who sometimes worked only one or two days a week at paying jobs, these gardens became important to the well being of their families.

These young women friends standing outside of St. Kevin Church in the late 1940s are, from left to right: Carmen Arias, Faye Martínez, Isabel Alcalá, Olga Martínez, Minerva González, Victoria Ruíz, and Loretta Cuellar.

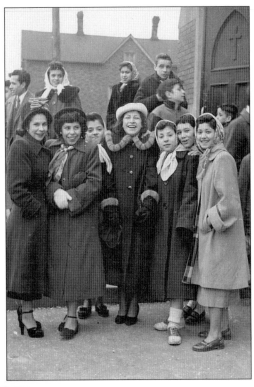

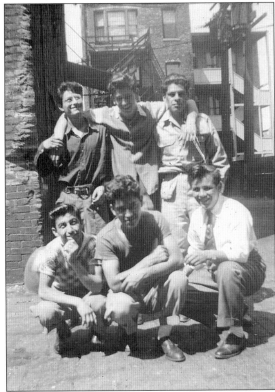

This group of friends hanging out on the corner of Harrison and Laflin includes: (top row, left to right) Jean Moreno, Steven Diaz, and Melitón "Mel" Moreno; (bottom row, left to right) Oscar Luna, Isidro Moreno, and Adalberto, c. 1945–46.

Family celebrations included showers for new brides and new mothers. Shown here at a shower c. 1940 are four women including Beatrice Munjeras and Vicki Villanueva.

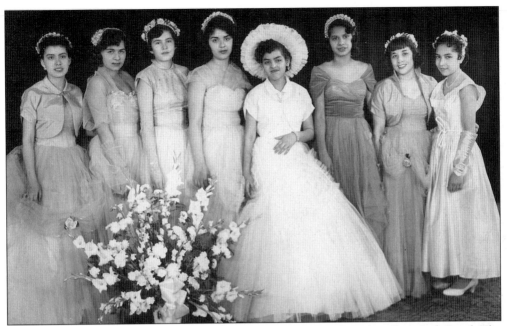

The site for this 1955 Quinceañera was at Turner Hall Centro Social on Roosevelt Road. The young women, from left to right, are: María Luisa Ramírez, Ofelia Ramírez, Blanca, Amparo, Margarita Ramírez (the Quinceañera birthday girl), Emma Ramírez, Lita Palos, and Beatrice Rivera.

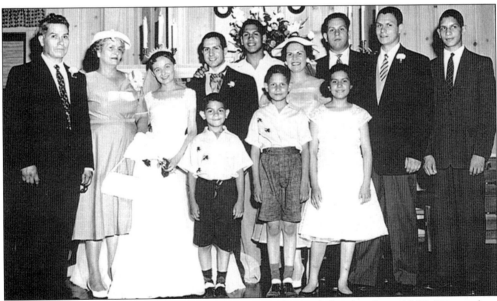

This wedding portrait is of Jesús Mota and Jane Staley with his family in 1957. His mother, Carmen Carrillo Mota, is featured as a young mother in South Chicago in an earlier photograph on page 34. The Jesús Mota family, originally from Momax, Zacatecas, and Michoacan, moved from South Chicago to the west side and were parishioners at St. Charles Borromeo Church located at Hoyne and Roosevelt. The smiling little boy in dark shorts, Ray Mota, has grown up to become the head of Chicago's leading Mexican construction company.

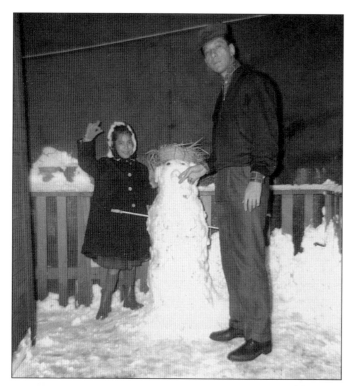

One of the nation's leading Mexican writers, Ana Castillo, was born in Chicago. In this photograph she is shown building a snowman with her father in the late 1950s or early '60s. Ana grew up in the Taylor Street neighborhood. Among her many book titles are *The Mixquiahuala Letters*, *Massacre of the Dreamers*, *So Far from God* (winner of the Carl Sandburg Award), and the poetry collection *My Father Was a Toltec*.

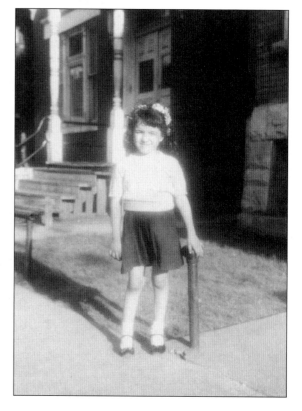

Sandra Cisneros is also considered one of the nation's leading Mexican writers. She is shown here *c.* 1959 in front of one of the Chicago homes that helped form the background for her book *House on Mango Street*. The house pictured here was located at 3847 West Grenshaw. This novel is often used as a text in junior high and high school classrooms, encouraging many young people to find a way to give voice to their life experiences. Sandra, who has since relocated to San Antonio, was awarded a MacArthur Foundation "Genius Award."

Taken in the 1950s, this photograph shows three grandchildren of José and Luisa Muñoz seated next to a traditional altar in their grandparents' home at 9031 South Brandon. These home altars are still seen in Mexican homes and reflect closely held spiritual traditions.

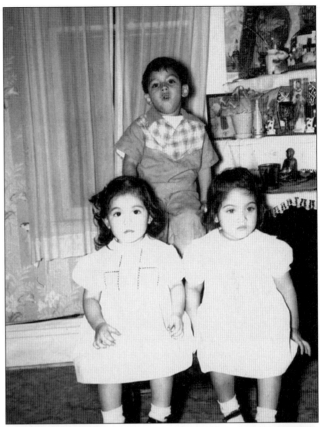

This photograph, taken at a child's birthday party in the early 1950s, is of a girl trying to break a piñata. The party took place in her home on Polk and Independence. Few Mexican families lived in this neighborhood at the time. It was the first time many of the Medina family's neighbors, mostly European immigrants, had ever seen a piñata, a custom brought to Mexico from Italy.

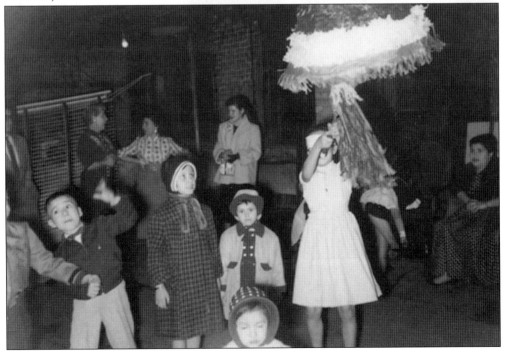

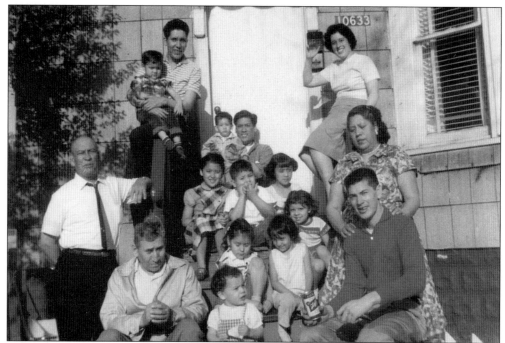

The Alvárez, Casteñada, and Rodríguez families are shown on the front porch in South Deering in 1960. Mr. Castañeda, the patriarch pictured in the shirt and tie, arrived in Chicago in 1921 with his brother from Teúl de González Ortega, Zacatecas. On his way to Chicago, he worked in agriculture in Kansas and in an automobile plant in Detroit. After arriving in Chicago, he worked at Carnegie Steel, U.S. Steel, and Wisconsin Steel, retiring after 45 years as a steelworker.

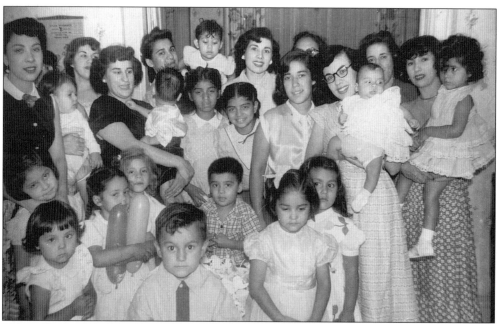

Milton Moreno and family gathered for his third birthday, c. 1953. The family lived on Rockwell Avenue in Humboldt Park. Milton later served in Vietnam.

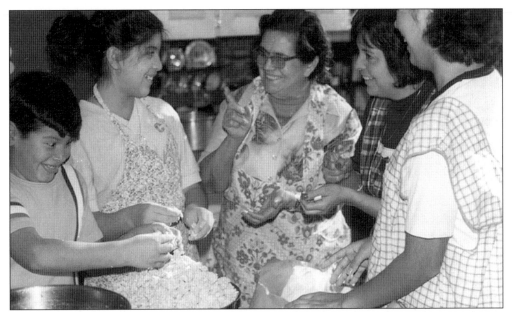

Grandmother Ruíz is shown here teaching her grandchildren about the intricacies of *masa* (corn dough)—the critical ingredient in making tamales. These family gatherings to make tamales are called *tamaladas*. Family recipes and tamale making techniques are taught at these gatherings. Families and friends all have assigned jobs: some mix meat and masa, others spread the masa on cornhusks or add the fillings, while there is always someone in charge of stacking the finished products for steaming. Tamales are served at Christmas and other special occasions.

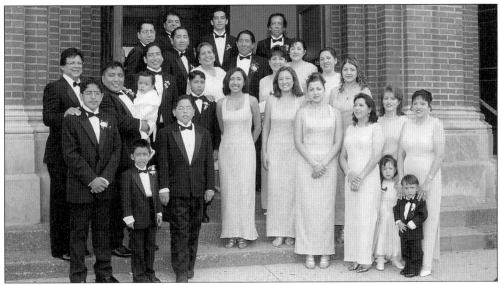

Pictured here in front of Providence of God Church are Jesús and Carmen Macías and their family at their 50th wedding anniversary in 1997. Mr. Macías first came to the United States at the age of 23 to work in agriculture as a *bracero*. As a bracero agricultural worker, he traveled to Colorado, California, Arizona, Michigan, Minnesota, Utah, Georgia, Illinois, Texas, Nebraska, Wisconsin, and New York. He returned to Ocampo, Guanajuato, to marry in 1947. He brought his family to Chicago in 1965.

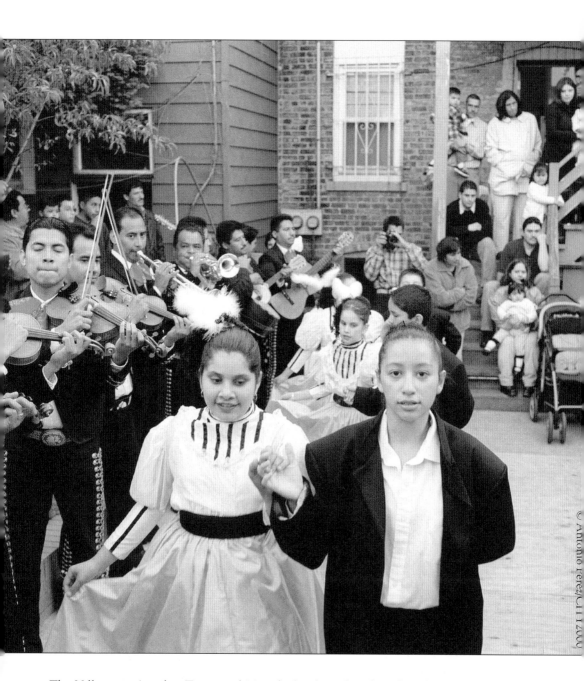

The Villaseñor, Amador, Torro, and Macedo families of Little Village have been celebrating Mother's Day this way for the past 12 years. Pictured here with the mariachi band Jalisco, children dance while their fathers prepare and serve food.

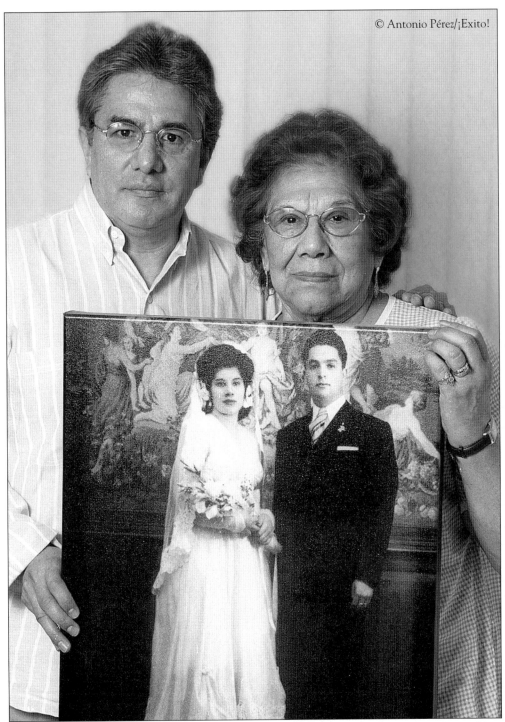

Ruth "Cuca" López and her son Arthur are shown here holding a photograph taken on her wedding day to her late husband Javier López. Her husband was contracted to work by the Burlington Railroad as part of the Bracero Program. She is a participant in a lawsuit that is trying to collect and distribute the unpaid pensions of bracero workers from the U.S. Railroad Retirement Board.

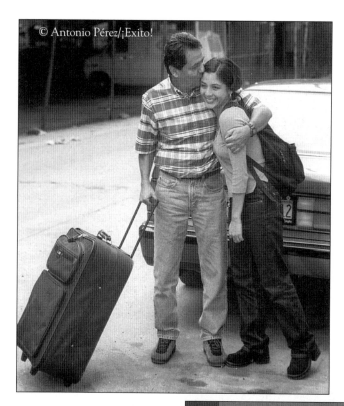

© Antonio Pérez/¡Exito!

Emiyuki Romo Chang is pictured here saying goodbye to her father just before she boards a bus bound for University of Illinois at Urbana-Champaign to start her college career.

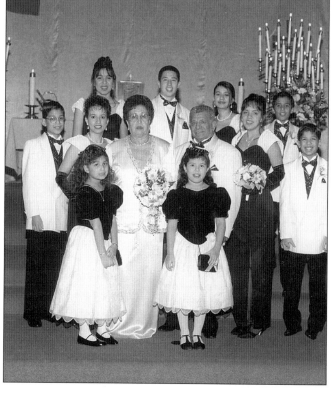

Shown here are Calixto and Celerina Arroyo celebrating their 50th wedding anniversary in 1996. Pictured with them are their grandchildren. The celebration took place at Immaculate Conception Church in South Chicago. Calixto also is shown on page 18.

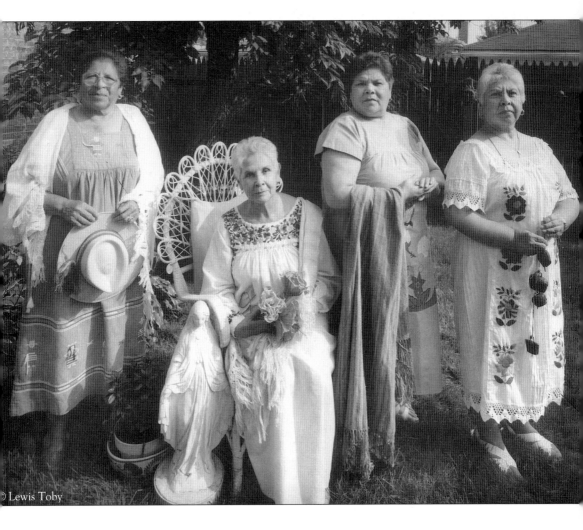

© Lewis Toby

This portrait was taken by Lewis Toby as one of a series of portraits for a collaborative project done by Chicago's Department of Cultural Affairs and the Coalition of Community Cultural Centers in 1995. This project, which included a traveling exhibition, billboards, and weekly profiles in the *Chicago Sun-Times*, highlighted five ethnic communities and cultural institutions. Captured in this image are the Martínez sisters who grew up in South Deering: Olga García, Carmen Arias, Martha Martínez, and Maria Ofelia Torres. Carmen Arias is the child whose name was written on the back of her mother's alien head tax entry permit on page 11; she and her sisters are also on page 37. They have lived in Chicago since the early 1920s. This black and white photograph became one of the most widely recognized images of the exhibit.

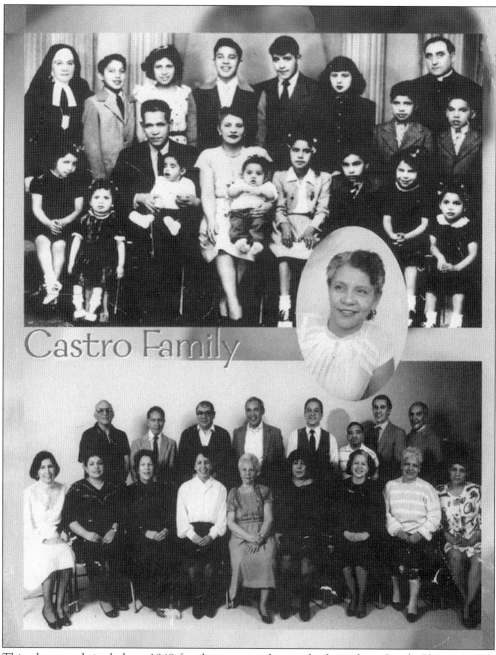

Castro Family

This photograph includes a 1948 family portrait taken with clergy from South Chicago's Our Lady of Guadalupe Church, and a 1970 photo from a family reunion. This composite photograph illustrates a way that the Castro family has used to document and preserve family history. Members of the Castro family have always been active in community affairs.

Three

COMMUNITY LIFE

L ife in Chicago's Mexican communities reflected the societal realities of each decade, especially changes in the official immigration policies of both governments. Most immigrants of the early 1900s came from rural areas, fleeing political and economic unrest. They found a labor pool that had been depleted by World War I and the Immigration Act of 1917, which significantly reduced European immigration. Their work as laborers in different industries was critical, but not well paid, and not without racial discrimination.

Housing was often difficult to obtain, and many families found themselves living in poor quality housing that had been built quickly and was not meant to last for a long time. The housing stock available to them has been described as dilapidated, dreary, and inhospitable. Boarding houses were common, especially for single men.

The Depression brought with it a loss of economic opportunities and a resurgence of xenophobia with heightened racist attitudes towards Mexicans. Efforts to repatriate Mexicans, to send them back to Mexico in order to prevent them from becoming "public charges" were not as widespread in Chicago as in Indiana and other states. These repatriation efforts resulted in individuals being deported without just cause, sometimes even when they held appropriate documents and United States citizenship. Families also participated in "voluntary" repatriations when they found themselves completely without resources. Returning to the harsh conditions in Mexico proved difficult for those who were forced to repatriate and those who left the United States "voluntarily" as related by Jesús Alvarado, who "voluntarily" returned with his family. It is important to note that voluntary repatriation was done by families and individuals under duress. Others decided to stay, especially those whose children had become *agringados* or Americanized. "My father decided not to leave, he figured if we were having a hard time here, life in Mexico would be harder," commented Olga García.

In all of the most important aspects of community life, the family remained the nucleus, the anchor. This included traditional nuclear families, and also those networks of *compadres*, and *paisanos* (people from the same village or town) who became part of the extended family.

The Mexican colonies identified in 1927 by Paul Taylor in his comprehensive work, *Mexican Labor in the United States,* included: Hull House and an area west up to and beyond Ashland, three colonies around the stockyards, Brighton Park west of Kedzie between 37th and Pershing Road, South Chicago, and Irondale. In addition, the University of Chicago Settlement also served a population of Mexicans beginning in approximately 1919.

Since its beginnings in the early 1900s, the official and unofficial immigration of Mexicans to Chicago and its surrounding suburbs and towns continues. There are still some vestiges of the original *colonias,* especially on the far south side, but neighborhood demographics have shifted. The Mexican community from the Hull House, Halsted, and Taylor areas were displaced. Expressways,

urban renewal, and the University of Illinois campus reshaped the old Hull House settlement. Some families moved to the newest Mexican *colonias* of Pilsen and Little Village, others to the established communities of South Chicago, South Deering and Blue Island, while still others moved to Mexican areas in suburbs and towns like Cicero, Berwyn, Blue Island, Elgin, Joliet, and Aurora. As time passed, the older communities that had grown up around steel mills, stockyards, and small factories also changed as these industries reflected larger economic trends and closed their doors.

The photographs included here highlight the development of a new urban mestizo culture with an identity that spans two nations. The members of these communities, who for the most part identify themselves as Mexican or Mexican American, maintained strong connections to the language and culture of Mexico.

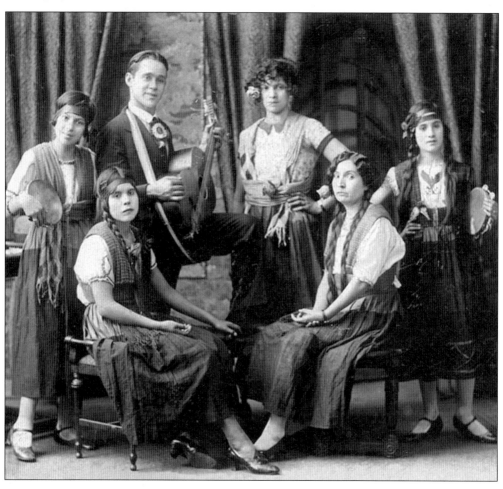

Pictured here is a theater group from Our Lady of Guadalupe in 1928. This group organized and presented theater and musical fundraisers for the church. One very appreciative audience for their parties were the *solos* (single men) who really appreciated the Mexican food that was sold. Included in this group are Angelina Hernández, María Ruíz, Javier Rodríguez, Carmen Mota, Teófila Martínez, and Otilia Martínez.

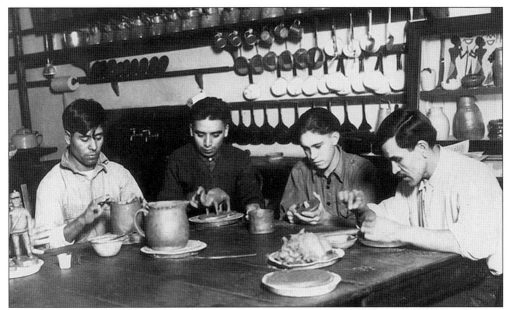

These young men are shown working in the pottery shop at Hull House. As Mexicans arrived to this neighborhood they took advantage of many settlement house programs, even though there were occasional racial incidents with members from other ethnic groups. (Photo courtesy of the University of Illinios at Chicago.)

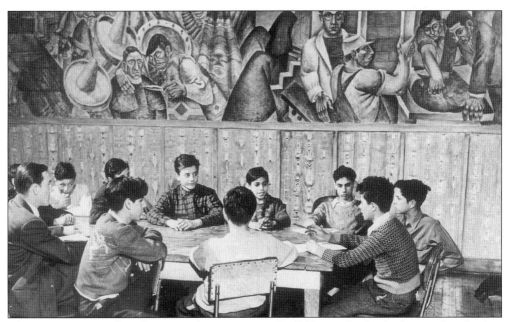

The young men in this photo are also meeting at Hull House. In the background is the first Mexican mural painted in Chicago. It was done by Adrian Lozano, and it includes a self portrait of the artist, who is shown in the center with glasses. The mural is strongly influenced by the Mexican muralist movement. This mural was destroyed during one of Hull House's renovations, and this is most likely the only remaining photograph. (Photo courtesy of the University of Illinios at Chicago.)

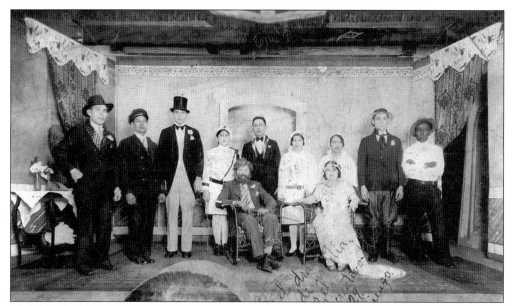

Photographed here sometime in the late 1920s is a drama group made up of parishioners from Our Lady of Guadalupe Parish. They are pictured on the parish stage. They performed theatrical works in both English and Spanish.

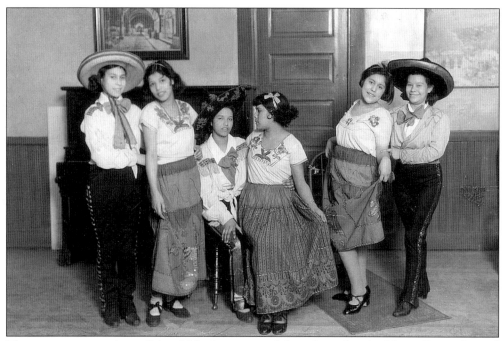

These young women in traditional Mexican regional dress danced at the Marcy Center located at Maxwell and Newberry. Marcy Center was originally begun as an outreach and welfare center by the Methodist Episcopal Church. The group pictured here includes Jovita Durán and Susie Gómez. Several of these young women also performed Mexican folk dances at the 1934 Century of Progress. As Susie Gómez remembered, "I danced at the World's Fair in the '30s, Isabel Baltazar was my partner."

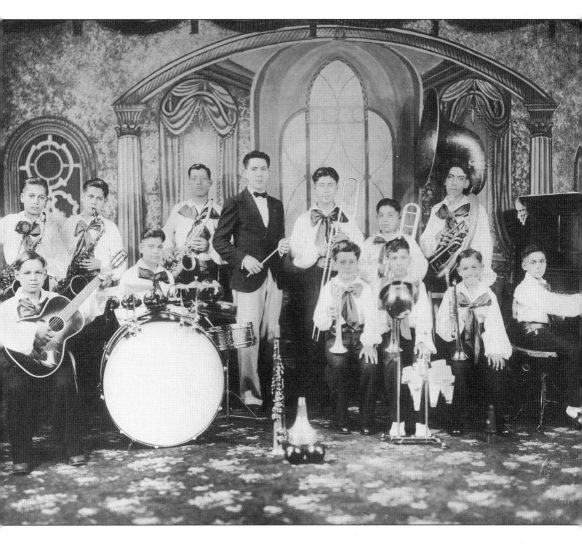

This photograph, taken c. 1917, shows a young men's musical group. Included in this photograph are: Milton Arias, guitar; Joe Artiaga, tenor sax; Miguelito Hernández, drums; Cornelio Arias, alto sax; Beans, trombone; Marty Martinez, trombone; Hildo Vera, tuba; Roman Castañeda; and Justino Cordero at the piano, who is pictured in his wedding photo on page 29. The group leader was Guadalupe Vera. Music always has been an important part of Mexican community cultural life.

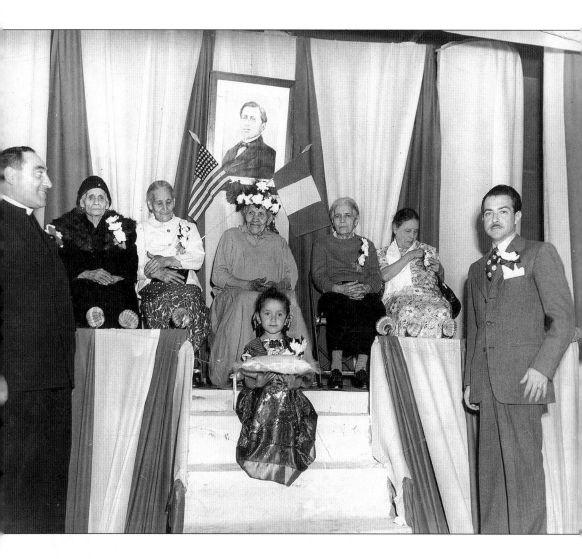

Día de la Madre, Mother's Day crowning with the oldest mothers, and the mothers with the most children are being honored by Father Catalina and a Mexican Consular official. The woman wearing the crown of flowers is Doña Pánfila Carrillo, who was about 102 years old at the time of the photograph. The "Festival en Honor de las Madres" was sponsored by the Organización Cultural Mexicana. Mother's Day is always celebrated on May 10th in Mexico.

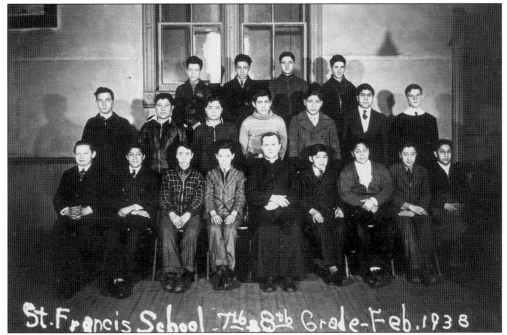

This photograph of the St. Francis of Assisi School 7th and 8th grade class, taken in February of 1938, includes Al Galvan. St Francis of Assisi became a religious, cultural, and social center for the Mexican communities on the near west side, and maintained connections with other Mexican colonias in South Chicago and Back of the Yards.

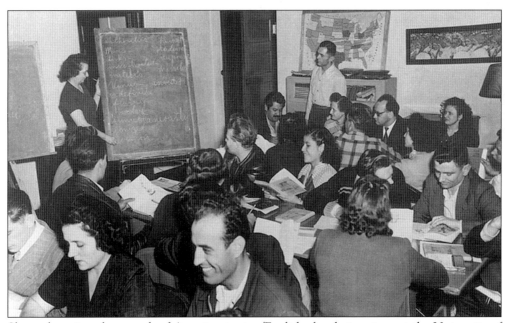

Shown here is a photograph of Americanization/English class being given at the University of Chicago Settlement House. There was a large colony of Mexican families in the area served by the settlement house under the direction of Mary McDowell. (Photo courtesy of the Chicago Historical Society.)

55

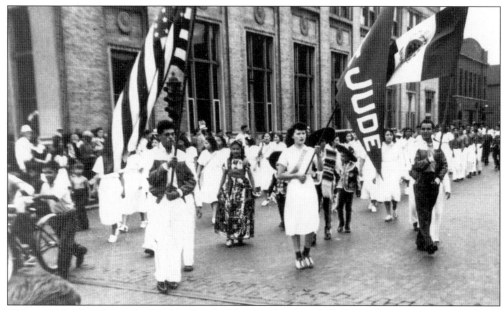

This neighborhood parade, held in South Chicago for the 1939 *Fiestas Patrias*, shows Our Lady of Guadalupe parishioners Ziggy Gamino, Coni Gallardo, and Mollie Mendoza marching behind the flags of the United States of America and the United States of Mexico.

Pictured is Manuel Monreal on the steps of a Pilsen boarding house in the 1950s. It was about this time that Mexicans began arriving in greater numbers in Pilsen after having been displaced from the Halsted and Taylor Street settlements. Mr. Monreal would later become a well-known restaurant owner and businessman in Pilsen and Little Village. Mr. Monreal came to the United States as a teenager and worked as a railroad dispatcher and a butcher before opening two restaurants—Manny's Steakhouse and La Fonda del Recuerdo. He was also very active in the 18th Street Businessmen's Association.

Zoot Suiters–South Chicago-style drapes "suits" are pictured here *c.* 1941. Friends on a porch at 91st and Brandon include: (front row) Ralph González and Joe Asencio; (back row) Joe Falcon, Frank Zúniga, and Eugene Rodarte.

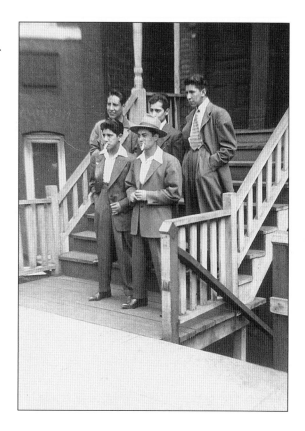

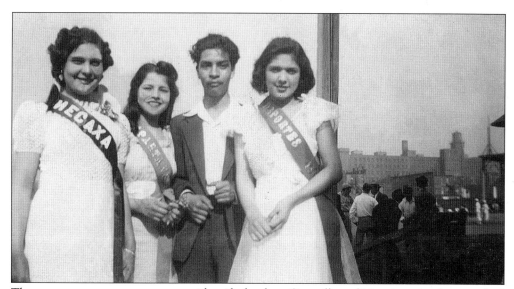

These young women soccer queens, identified only as Carmella and Maggie, were photographed on May 5, 1939, wearing ribbons with the names of the team they represented. These soccer teams were part of a large organized group of teams that played all over the city.

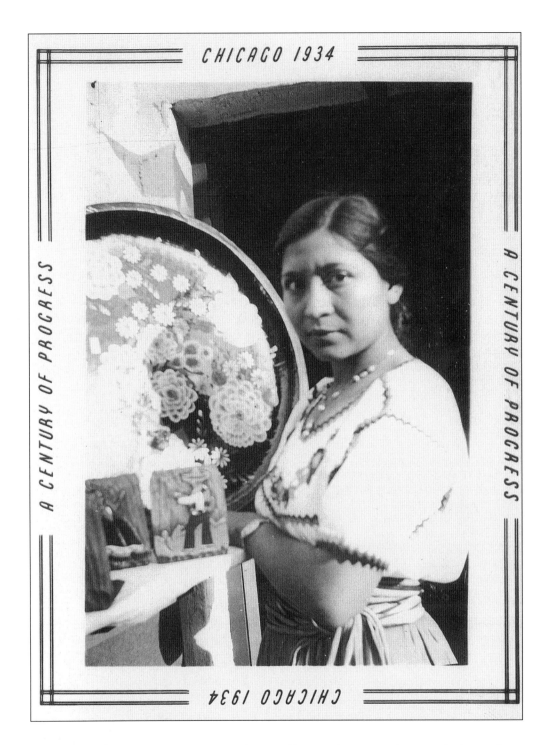

This photograph was taken in 1934 at the World's Fair (Century of Progress). Rosita Pérez worked at the Mexican Pavilion as a hostess selling Mexican craft items and dancing. It is somewhat ironic that the Mexican Pavilion highlighted Mexican art and culture during a time when many Mexicans were struggling against repatriation and deportation.

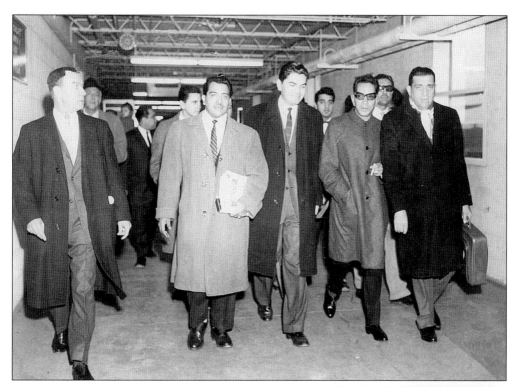

In addition to bringing Spanish language movies from Mexico, Chicago impresarios such as Alejo Silva Díaz brought famous cinema stars, singers, and other entertainers to perform at places like the Amphitheater, the Tampico, the Senate, and the San Juan. Pictured here, second on the right, is Mario Moreno—Mexico's most famous movie star comedian also known as Cantinflas.

The Gayety Theater in South Chicago was one of a handful of Spanish-language theaters throughout the city. Shown here in the 1950s, it was owned by the Gomez family. In addition to movies, it also showed news reels produced for Mexico. An outing to the "show" usually included a stop at Gayety's Candies and Ice Cream Shop next door. (Photo courtesy of the Southeast Historical Society.)

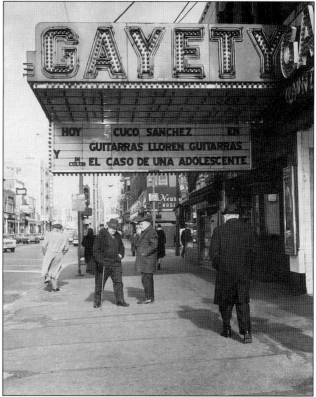

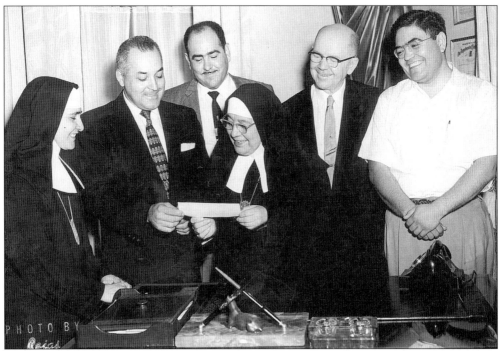

Mother Marie Ramírez of the Cordi Marian sisters is shown here receiving a check from a group of Mexican-American business men c. 1950. Pictured, from left to right, are: Frank Durán, Mario Dovalina, Dr. Joseph Tobin, and Arturo Velásquez Sr. Also pictured is the Mother Superior. The Cordi Marian sisters came from Mexico during the time of religious persecution and worked in all of Chicago's Mexican communities.

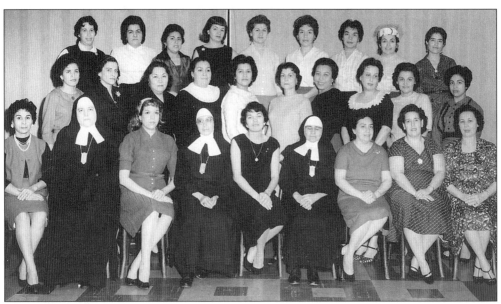

Pictured here with Cordi Marian sisters are members of the Cordi Marian Women's Auxiliary. In addition to working with Mexican communities, the Cordi Marians sponsored a yearly Cotillion based on the traditional Mexican Quinceañera or 15th birthday celebration.

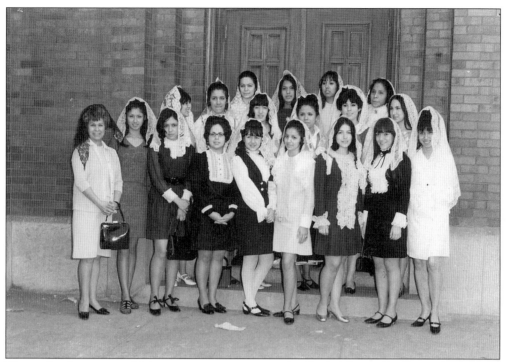

This is the first group of debutantes participating in the Cordi Marian Cotillion of 1969. The girls are all wearing traditional lace mantillas.

Shown here dressed in their formal white dresses are the Cordi Marian Debutantes at the first Cotillion held in 1969. Held yearly as a fund raiser for the Cordi Marians, it provided young women with an opportunity to take part in an old Mexican social and cultural tradition. The idea for this first Cordi-Marian Debutante Cotillion has been credited to Shirley Velásquez.

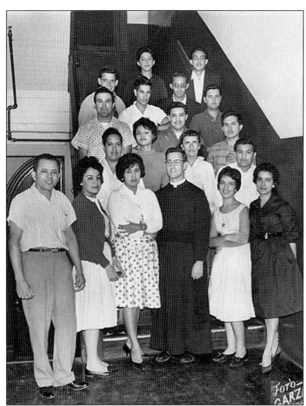

Juventud Obrera Católica (Young Catholic Workers) group is shown with Father Pedro Rodríguez from St. Francis of Assisi c. 1960.

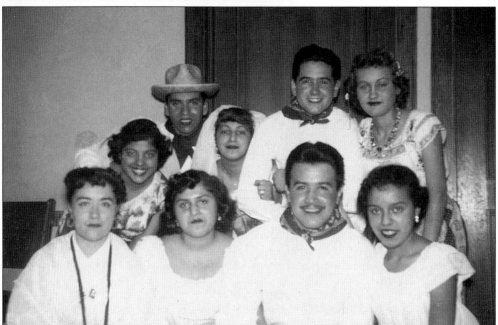

In this photograph are members of the Chicago Fiesta Guild from Back of the Yards. They participated in many citywide ethnic festivals including "Christmas in Old Mexico" at the Museum of Science and Industry in 1962.

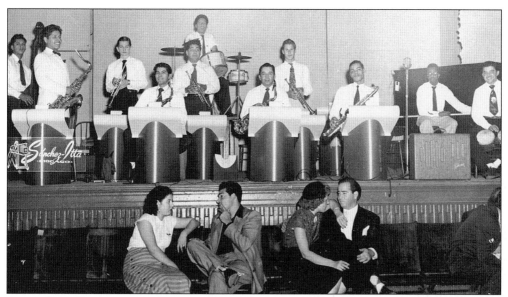

A popular musical group, Urbano Medina y sus 16 Diablos del Mambo, played for many social occasions such as banquets, weddings, and dances. The musicians that formed the group included: Roman Castañeda, drums; Urbano Medina, sax; Ralph Medina, trumpet; Chendo Moreno, bass; Simon Carrizales, sax; Ron Carlson, trumpet; and Wally, piano.

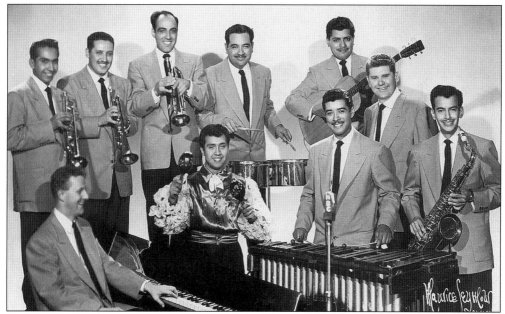

A very well-known group with South Chicago roots, Don Roberto and the Rumbaleros, played from 1948 through 1974. The band toured the Midwest and played in Illinois, Ohio, Indiana, Wisconsin, and Iowa. In Chicago they were part of the regular music circuit, playing in such places as Croatian Hall, Barney's Grill, the Hilton Hotel, the Edgewater Beach Hotel, and various church halls. The group members include John Campos, Ed Caliguri, Joe Fatigato, Ray Castillo, and Louie Cabrera. In the first row are George Saukoup, Paul Domínguez, Bob Cabrera (a.k.a. Don Roberto), Leo "Red" Rodríguez, and Abe Vásquez.

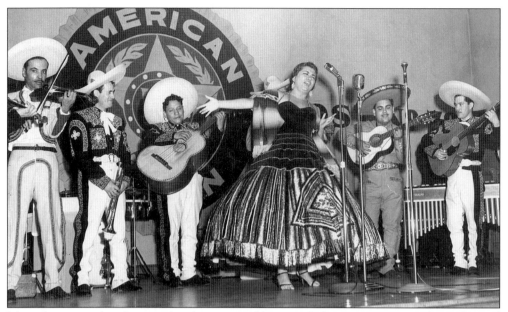

Mariachi groups played at social gatherings, weddings, and christening parties. The traditional music was for singing and dancing. The vocalist shown here is performing on a stage in front of an American Legion logo. Traditional Mexican music continues to be an important cultural connection, the word *mariachi* is said to have come from the French word *mariage*, used during the time Maximilian and Carlota were in Mexico to describe musical groups who performed at weddings.

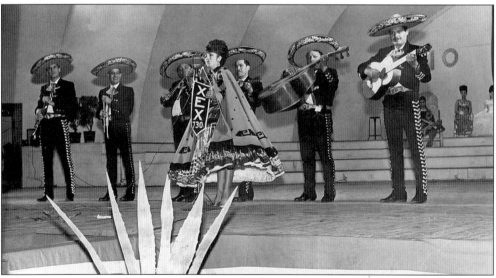

Pictured here is a celebration of the *Fiestas Patrias*, 15th and 16th of September holidays commemorating the 1810 Cry of Freedom, called in Spanish *El Grito de Dolores*. Here the celebration takes place in the old Grant Park Band Shell, or *La Concha*. The *Concha* was rented for $350 for the first grito remembered Raúl Gonzalez, former member of the Círculo Jaliciense. A huge crowd showed up for the first parade and *Grito*. Mayor Daley appeared at the Bandshell and said, "I want to thank you for a wonderful parade." He then proclaimed the week of September 15th "Mexican Week."

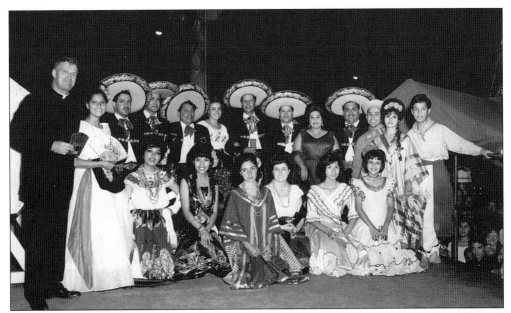

A performance group from Immaculate Heart of Mary Church is shown here dressed in traditional regional dress.

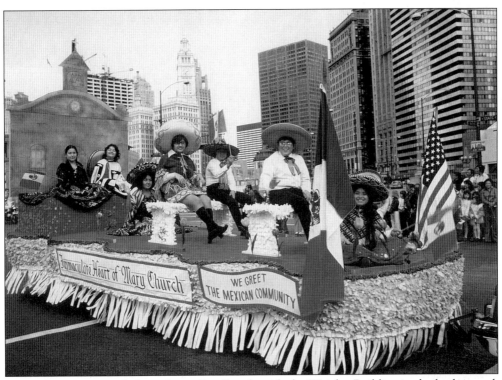

Pictured is a Mexican Independence Day Parade with the Wrigley Building in the background. This float was sponsored by the Immaculate Heart of Mary Church from Back of the Yards. *La Sociedad Civica Mexicana*, the Mexican Civic Society, has for the past 40 years coordinated this downtown celebration.

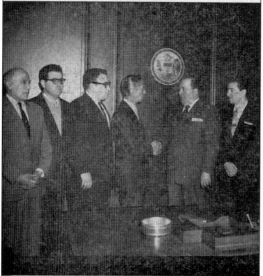

Agustin Lara Compondra el Himno para los III Juegos Panamericanos

COMPARTIENDO AMIGABLEMENTE con el Alcalde Richard Daley, de izquierda a derecha: el Sr. Dn. Luis F. Moya, cronista deportivo de NOTICIAS, señor José E. Chapa, Sr. Carlos Gómez Jr. Agustín Lara, Richard Daley y Alejandro Algara. La entrevista fue en atención a la invitación que el Alcalde Municipal hizo al gran génio mexicano.

This newspaper clipping, from an unidentified Spanish-language newspaper in 1959, depicts the meeting of Mayor Richard J. Daley with the famous Mexican composer, Augustin Lara. Mr. Lara composed a musical theme for the Pan-American Games held during that summer.

Pictured here are many community leaders and members of community organizations that were involved with the Pan-American Games of 1959, held in Chicago and nearby suburbs. Chicago hosted athletes from all over Latin America, and many members of the Latino community worked with Jack Reilly from the Mayor's Office at that time.

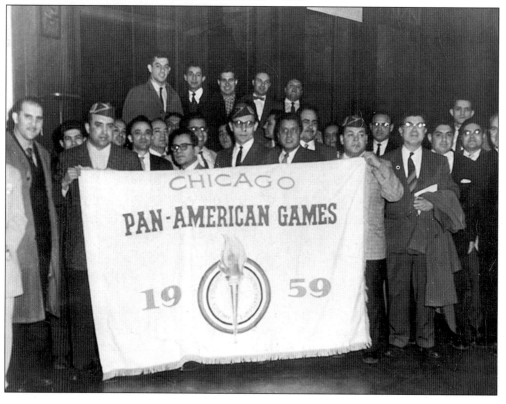

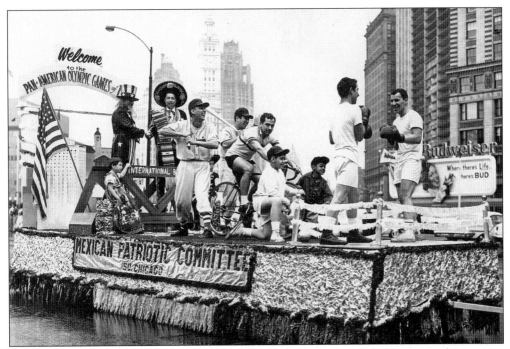

Shown here is the Mexican Patriotic Committee float in the parade held prior to the opening of the Pan-American Games during the summer of 1959.

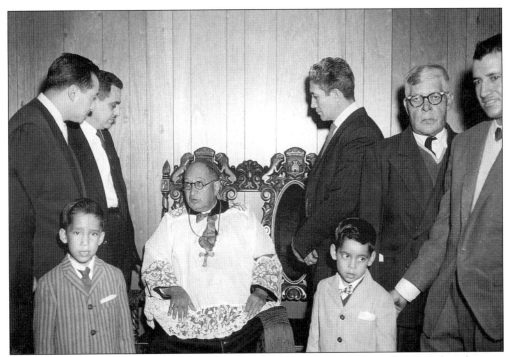

The Archbishop of Guadalajara is shown here with businessmen from the Círculo Jaliciense who helped raise money for disaster relief after the Guadalajara earthquake. Included in this photograph is Raúl González, one of the founders of Círculo Jaliciense, pictured first on the left.

Soberana LULAC, 1959

LA ENCANTADORA María Luisa Ramírez del 2714 al sur de la avenida Normal y originaria de Waco, Texas, fué, nombrada Reina LULAC 1959 por tres jueces del Concilio 288. La corte de la soberana la integran las señoritas Raquel Resendez, Vina Gómez, Dolores Santoyo y Amelia Garza quienes también concursaron en la elección de la máxima representación de Belleza de los miembros de LULAC. Su coronación tendrá lugar en el Louis XVI Room del Hotel Sherman.

Maria Luisa Ramírez, the 1959 LULAC (League of United Latin American Citizens) Queen, was crowned in a gala ceremony at the Sherman Hotel in Chicago. María Luísa came to Chicago from Waco, Texas. The organization that she represents always has raised money to give college scholarships to Mexican youth.

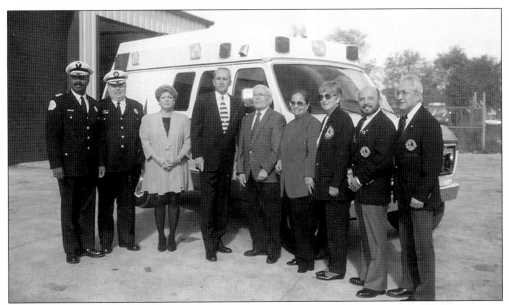

The Azteca Lions has been involved in many charitable acts for Mexicans in Chicago and in Mexico. This photo shows the Azteca Club donating an ambulance for Mexico. Pictured, from right to left, beginning with Arturo Velásquez Sr., fifth from the left, are Connie Salas, Emily Tellez, Vince Rangel, and Joe Tellez.

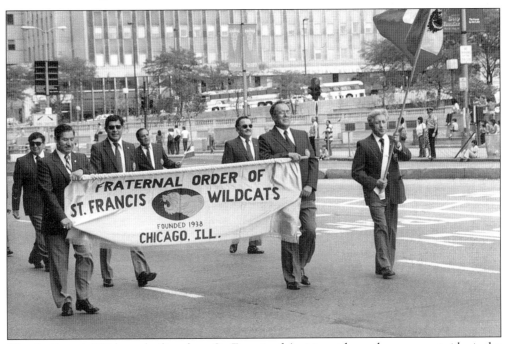

The St. Francis Wildcats, hailing from St. Francis of Assisi parish on the near west side, is the Mexican community's oldest continual fraternal organization. Although hardly any of the Wildcats live near St. Francis, they still maintain strong allegiance to St. Francis Church. They were also instrumental in saving St. Francis from being torn down in the 1990s. This group has organized innumerable events to assist the Mexican community.

The Mr. and Mrs. Society was organized in 1959 as a bowling league under the name of "The Mexican Mixed League." Not too long afterward, 10 couples who met socially after bowling formed a social club separate from the league. This social club grew into a not-for-profit philanthropic and charitable organization that stressed community service and scholarships. Shown in this 1991 photograph are Julia and Frank Martínez, Inéz and Alfred Galván, Lee Rocha, Evelina and Bernard Sauter, Mary and Manuel Martínez, Alice and John Heffernan, Emily and C. Joe Vallez, and founding members Nellie and Ignacio López.

Included in this photograph taken during a swearing-in ceremony c. 1976 are the officers of the Mexican Community Committee Joseph Guadalupe Mendiola, John J. Mendiola, Frances García, Nancy Arias, and Raymond Arias. The MCC remains an important community organization in South Chicago.

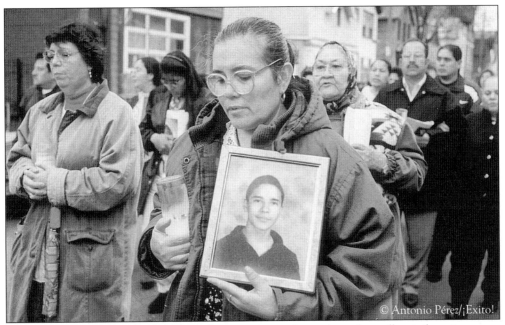

© Antonio Pérez/¡Exito!

This moving photograph was taken during a parents' march and candle vigil against gang violence. The issue of gangs and their destructive presence haunts urban communities throughout the United States. Pictured here is Robertina Arellano holding a photograph of her son, Erik Arellano, who died as a result of gang violence during the summer of 1995. Unfortunately, much of the mainstream media never covers the positive accomplishments and attributes of young Mexicans, preferring to only emphasize the negative aspects of Mexican youth.

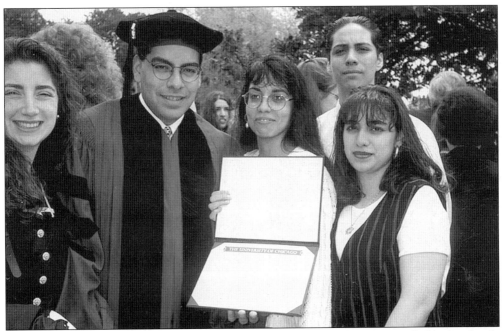

Jesse Muñoz, dressed in his graduation cap and gown, is shown here surrounded by his family after being presented with his Juris Doctorate from the University of Chicago in May of 1995.

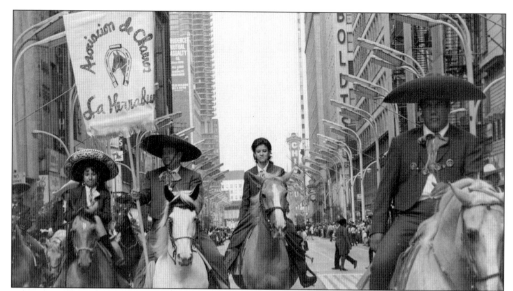

Above is the first Mexican parade held on State Street. Pictured here is "La Herradura," a member of the Charro Association that was founded to continue the traditions of the Mexican *charro*, or gentleman cowboy. Most of the members of these associations owned their own horses. In addition to participating in parades, groups sponsored *charreadas*, or Mexican rodeos. At the time of this parade, Mayor Daley was reluctant to close State Street for this event because that would mean losing $1 million in revenue. According to one of the parade's founders, Raúl González, "Daley said, 'Son, I'm going to give you half the street.' By the time the parade got to Madison we had taken up the whole street from the river to Congress!"

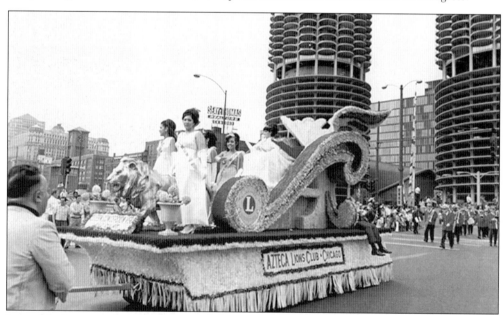

Large Mexican parades always featured floats sponsored by service organizations such as this Azteca Lion float carrying a Queen and her court captured here with Marina Towers in the background. Parades such as this one are still used to celebrate the *Fiestas Patrias* and *Cinco de Mayo* traditional holidays.

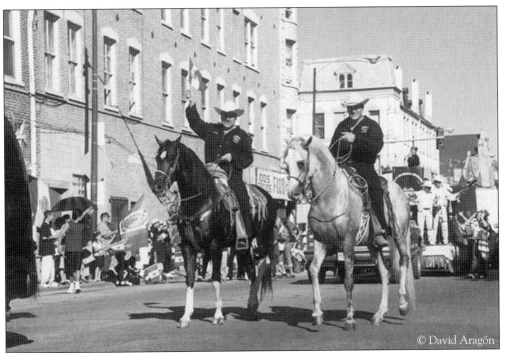

Mounted horsemen in a 26th Street parade preserve the tradition of *el norteño*, the cowboy from the north.

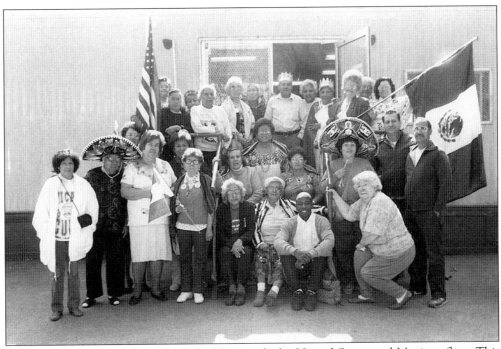

Harrison Park seniors are photographed here with the United States and Mexican flags. This senior group remains very active and participates in activities from folk dancing to arts and crafts.

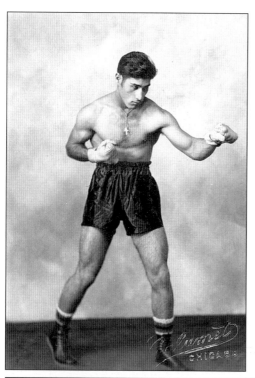

Aurelio "Spinks" Salas was boxing champion for Our Lady of Guadalupe, the CYO, AAU, and the Golden Gloves. The center of the fighter association was at St. Sabinas Parish on 79th Street.

Captured here in 1946 is a group called Pro Mexico, which was originally founded in 1938 in South Chicago. They were a beneficent organization that helped organize and outfit sports teams.

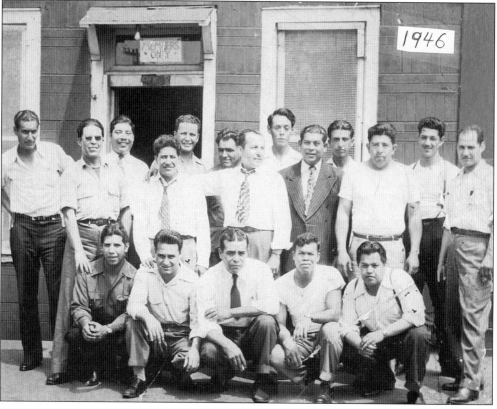

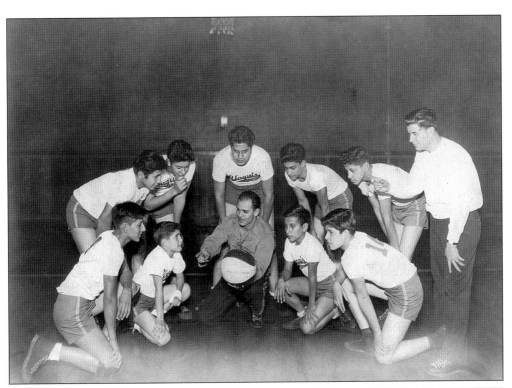

The gym at Bird Hall was the site of many intense athletic competitions. Pictured here, from left to right, are: (top row) Frank Ayala, Zenon Ortega, Benjamin Valadez, Rosendo Moreno, and Eddie Peralta; (bottom row) ? Islas, Ruben Flores, Jessie Martinez, Joe Jáquez, and Wilfred Ramírez.

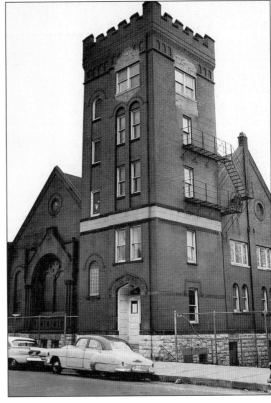

Bird Memorial Hall at 9135 Brandon Avenue was a Mexican church founded by the Congregationalists as an outreach to the Mexican community in South Chicago.

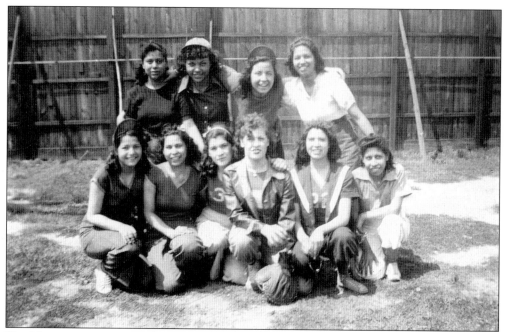

The Mexican communities also supported teams for women. Pictured here are the Moreloettes, a baseball team from the west side pictured here c. 1939. Southside girls' teams like the Amapolas traveled all around the city to play.

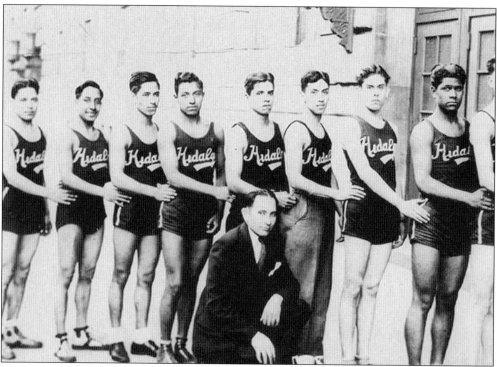

The Hidalgo senior basketball team is pictured in front of Crane High School in 1939.

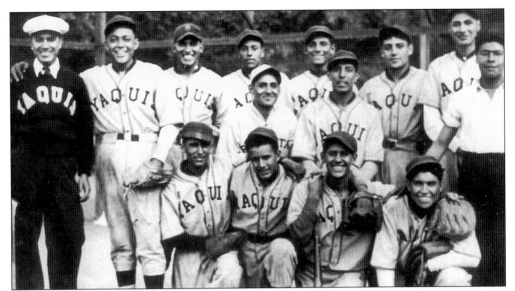

The Yaqui baseball team, pictured here in the 1930s with their coach, were part of an extensive Mexican Baseball League that included teams from all over the city and Gary. "Even though some of our players were major league quality they (the whites) didn't want them on their teams. Some of our players played against people like Satchel Paige," reflected Mike García, former organizer and manager for sports teams .

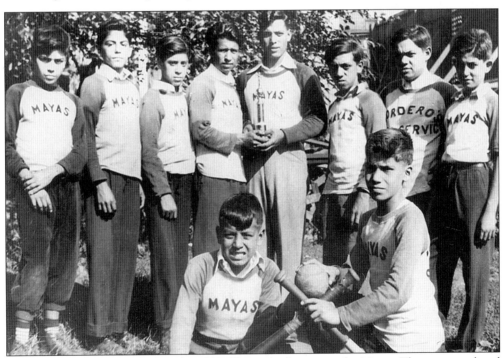

Shown here in Bessemer Park is the 1937 Championship team, the Mayas. These teams played in parks all over the city. "It was a Sunday tradition for Mexican families to go to church at five in the morning so that they could spend the whole day at the park playing and watching ball games. We traveled to the games by street car wearing our uniforms," recalled Mike García.

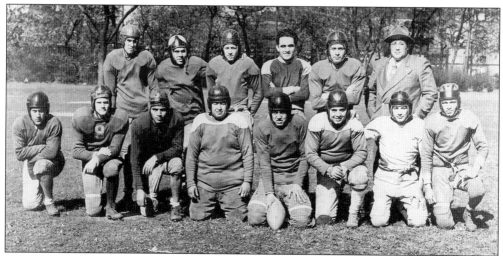

The Mexican communities fielded sports teams in many different sports. Pictured here is a football team from St. Francis of Assisi parish shown in Grant Park sometime in the late 1940s.

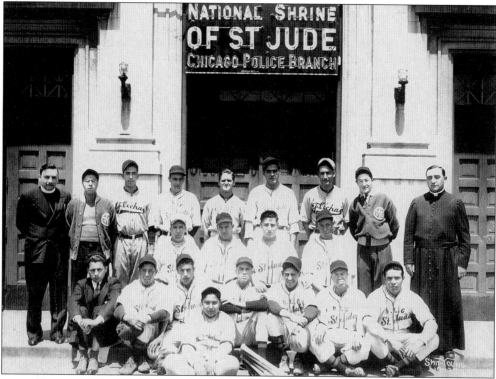

Pictured are a men's baseball team wearing team uniforms with the names Our Lady of Guadalupe and St. Jude in the late 1940s. The two names are used somewhat interchangeably, but St. Jude refers to the National Shrine of St. Jude established by Fr. Torte in the church. Sports were supported by both the Chicago Park District and by other churches in the diocese. According to Mike García, "We knew lots of guys from the West Side because we played against them. We all participated in fundraising dances, banquets, and other activities. Some of us even met girls from other neighborhoods and married them."

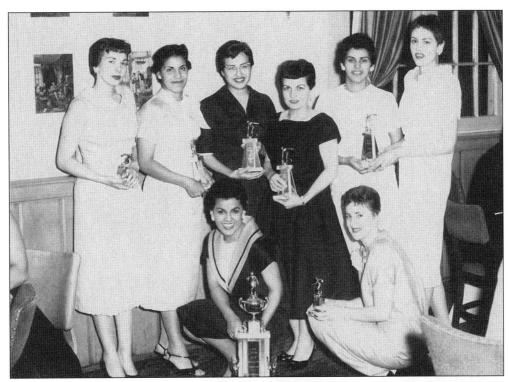

Another popular sport in the Mexican community was bowling. Shown here are league members with their trophies at the Bamboo Inn in Chicago, from left to right: (top row) Lupe Morario De Pozo, Jennie Franco, Emily Valadez, Frances Angel Rodríguez, Josephine "Fina" González, and Delia Mendoza; (bottom row) Ortie Romo and Alice Barba Alemán.

Pictured here c. 1960 are members of a Women's Bowling Team that was part of the Mexican Bowling League. Pictured, from left to right, are: (front row) Martha Martínez and Carmen Mendoza; (standing) Sid Valencia, Marcella Ochoa, and Amelia Morales. This bowling association, known as the Mexican Bowling Association, had male and female teams. Teams from Indiana Harbor (right across the border from South Chicago) also played in the league.

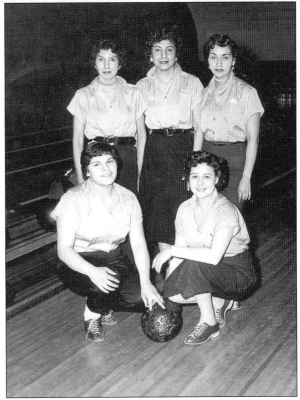

79

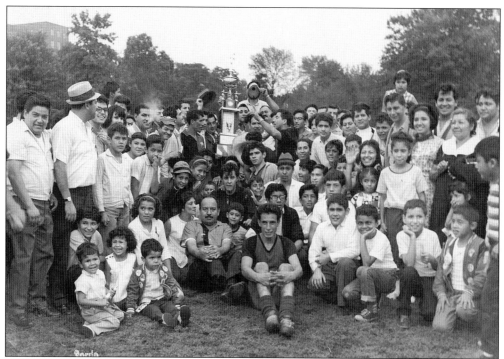

Pictured are soccer clubs El Atlas and La Porra in Douglas Park in 1966. Included in the photograph are Armando Almonte and well-known goalie Manuel Canchola.

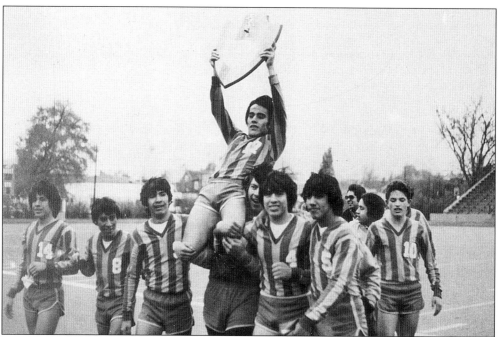

Alberto García is carried off the field as Bowen High School wins its third consecutive City Soccer Championship. The 1981 City Champs were a predominantly Mexican team and one of the several overwhelmingly Mexican high school teams that have won the city soccer title.

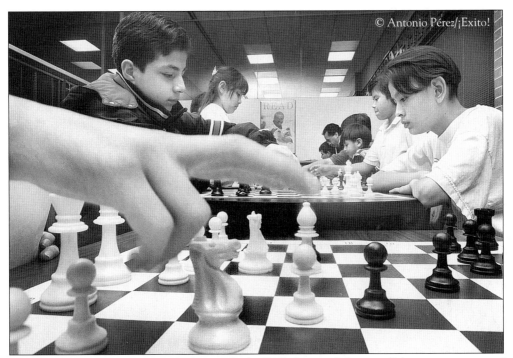

© Antonio Pérez/¡Exito!

Head Librarian Hector Hernández has made the Rudy Lozano Library in Pilsen into a mecca of future chess masters. The young participants in this program have done extremely well in numerous regional tournaments.

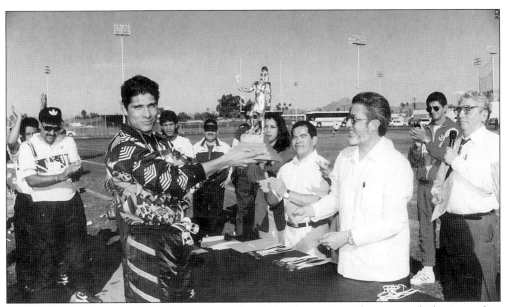

Genaro García, captain of C.L.A.S.A., is shown here receiving the national championship trophy of the 1995 Copa México in Phoenix, Arizona. C.L.A.S.A. (Chicago Latin-American Soccer Association), which consists primarily of Mexicans, has operated soccer programs for adults and children. C.L.A.S.A. also won the 1994 and 1998 Copa México tournaments. (Photo courtesy of C.L.A.S.A.)

Six friends are standing in front of the Steel City Bank in South Chicago right before registering for the armed services. Mexican soldiers were among the most highly decorated ethnic groups during World War II. They served in all theaters of the war and were awarded many medals—including 12 who were awarded the Congressional Medal of Honor. The young men pictured here are Gilbert Muñoz, Natividad Muñoz, Willie García, Jessie Martínez, Frigo Falcón, and John "Spider" Guzmán.

→

Reproduced opposite is a page from the *St. Francis Crier,* a newsletter published by parishioners from St. Francis of Assisi. It is taken from the World War II collection of newsletters compiled by Ramon F. Barba. Published once a month for the price of 5¢, it served to maintain contact between servicemen and women and their home.

This issue relates the bravery of PFC Manuel Pérez who was posthumously awarded the Congressional Medal of Honor. He was one of over 500 young men and women who served in the armed forces from this one single parish. The compilation of these newsletters is dedicated to "the men and women of the Mexican-American barrios of Chicago, Illinois, who served this country and died defending their beliefs."

St. Francis CRIER

Published Once A Month — ENGLISH and SPANISH

PRICE 5 CENT

VOLUME II. AUGUST, 1945 NUUMBER

Congressional Medal of Honor Awarded
Posthumously Private First Class Manuel Perez

One of His Buddies Depicts Our Soldier's Valor

It was on the 11 p. m. News Broadcast, Thursday, July 19th, when we first heard of it.

The announcer was reporting the awarding of the Congressional Medal of Honor on that day on Luzon to one of our Chicago boys. The name, PFC. MANUEL PEREZ.

We couldn't believe our ears, yet we knew that this heroic Chicago Chutist of whom he was talking, was our old friend and neighbor, Manuel, known to many of us as "Skeesix."

Socially Inclined

We all remember Manuel as one of the original members of the Club Juárez, and also the founder of the Cyclist Club. Manuel played on the various teams, and was an all-around social lad, noted for his dancing ability and cheery disposition. To many of us he was more than that, he was a close friend with whom we had gone to school and grown up with.

The story, as told on the radio that night and printed in all the papers the next morning, how Manuel had knocked out 12 pillboxes and killed at least 75 Japs to win the Congressional Medal of Honor, was related in detail by one of his buddies, Sergeant Max Polick, of Medina, N. Y.

A Buddy Tells the Story

Polick told the story as follows:

"Our company was attacking the line of Jap emplacements which defended the high around ahead of us in depth.

I was leading the squad on the right flank and Pérez was on my left. The Nip pillboxes were thickly covered by heavy sodding and logs. Smaller positions contained one to four riflemen, who covered the larger bunkers containing the automatic weapons.

The Japs were throwing direct fire from 2-mm. machine guns and there was not a helluva lot of cover.

Immediately behind the main line of fortifications was a big concrete bunker which housed twin-50-caliber machine

PFC. MANUEL PEREZ

guns. Pérez ran out, ducking this way and that, with an armful of grenades.

Courage by the Tons

We covered him with fire as he tossed his grenades into the ports and knocked out the guns. The only time he withdrew was to go back for more grenades.

Then he ran around to the front of the bunker and tossed in a couple of grenades. There was a helluva blast. Then Pérez climbed to the top and dropped two white phosphorous grenades through a vent.

I saw him flatten out and then the grenades exploded. There was a lot of white smoke. Pérez sat right in the middle of it, looking over at us and grinning. He held up his hand and made a circle with his thumb and first finger.

Hand to Hand Fighting

Pérez got the smaller pillbox next door by raising his rifle and firing four times into it. Japs were pouring out and he shot and killed eight with his rifle.

One Nip crawled out and charged Pérez from the rear. Pérez turned just as the Jap hurled his bayonet like a spear.

Prelados Ahora a Cargo de los Destinos de la Iglesia de San Francisco

Rev. Dr. Thomas Martin, C.M.F., el nuevo Párroco de San Francisco de Asís. El Rev. Dr. Thomas fué profesor de filosofía por cinco años, pero llevado del celo por la salvación de las almas, prefirió dejar la cátedra y dedicarse a la cura de almas en California, México y Texas, distinguiéndose en todas partes por su actuación desinteresada y abnegada en bien de todos, singularmente de los pobres, de los enfermos, de los apartados de la Iglesia, y más que nada, de la juventud de nuestra Colonia Mexicana. Poco tiempo lleva entre nosotros y ya todos saben de sus grandiosos proyectos a favor de los mexicanos de Chicago. Que Dios Nuestro Señor bendiga a manos llenas sus magnánimas empresas.

(Foto en la segunda plana)

Rev. Jaime Tort, C.M.F. Es un verdadero Apóstol de los Mexicanos. El fué quien inició la fundación de San Francisco, de Chicago; la de la Sma. Virgen de Guadalupe en Sur Chicago, y actualmente

(Pasa a la segunda plana)

Pérez used his rifle to knock down the flying bayonet. The shock knocked his gun spinning. Pérez grabbed up the Nip's rifle and bayonetted the howling Jay with it.

Four more Japs then started out of the pillbox tunnel. Pérez clubbed two to death, and bayonetted the other two. Then he entered the pillbox and found one live Jap. He bayoneted him."

Epilog

In a review at Lipa air strip, General Walker Krueger made the award posthumously to Manuel Pérez, for his heroic actions on February 12th, while with the 11th Air-Bone Infantry Division.

Manuel was killed by a sniper bullet on March 19, 1945, while covering his platoon's withdrawal from the edge of Santo Thomas, in Southern Luzon.

Manuel's father, Mr. Manuel Pérez Sr., and his grandmother, Mrs. Emilia Pérez, are now living in Oklahoma City.

The memorial card reproduced here was written for Charles Galvan, who was killed in action during World War II.

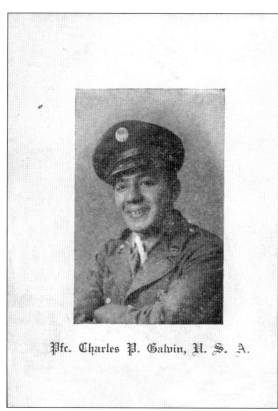

Pfc. Charles P. Galvin, U. S. A.

Pictured in this photograph is the repatriation of the remains of PFC Charles Galvan—one of the many Mexican-American veterans from Chicago who made the ultimate sacrifice for their country. He was posthumously awarded the Silver Star for gallantry and bravery in action while serving in Luzon, Phillipines.

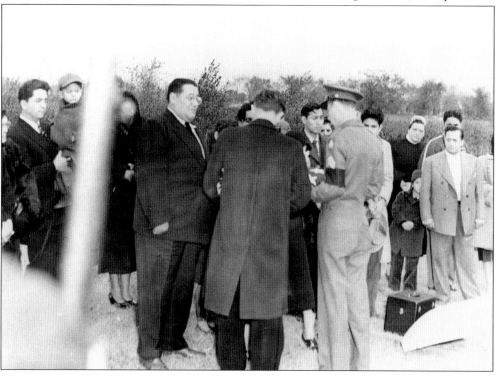

Mexican-American soldiers served in all theaters of operation during World War II. It is difficult to obtain accurate statistics about their numbers, because the Department of Defense has never collected data for Mexican soldiers; it only began to collect data with the "Hispanic" label for soldiers in 1979. Frank Estrada is shown here in a Florida boot camp before being shipped to the South Pacific. The postcard below was sent to Yance Martínez from Frank.

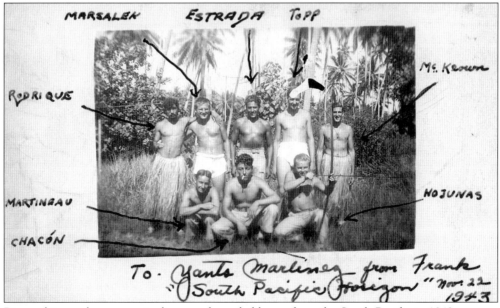

Pictured is another souvenir photograph mailed home from the South Pacific in 1943.

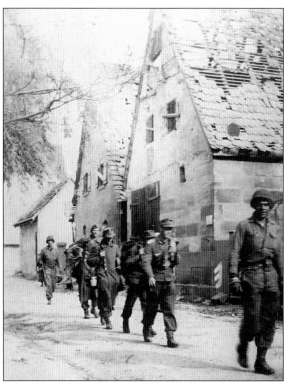

This 1944 photograph mailed home from overseas shows John Guzmán, who was later awarded the Silver Star, walking through a European village with German POWs. "We never knew that John was awarded the Silver Star until after he died many years later," related Yance Martínez.

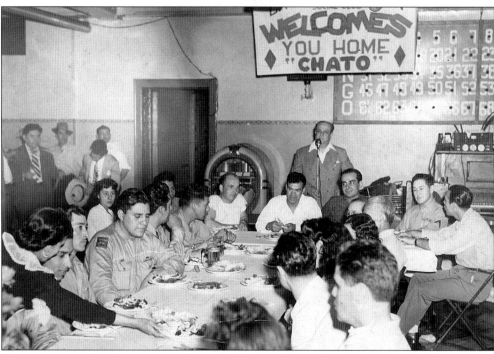

There can never be a better party than one that celebrates the safe return of a soldier from a war. This party for a Mexican soldier was held at Croatian Hall in South Chicago when "Chato" returned from active duty.

This portrait was used to announce the engagement of Jennie Dianda and Matt Estrada.

This touching photograph of Pete Martínez and his mother Frances was taken prior to his reporting to Korea. She is the same woman pictured working in the beet fields of Nebraska on page 15.

Shown here in Seoul, Korea are Lupe and Frank Valadez in December of 1953. All five brothers from this family served in the armed forces.

Joe Chávez Sr., pictured here, was born in 1926. He fought in both World War II and the Korean War. It has been estimated that Mexicans throughout the United States have served and have died in military service in larger percentages than any other group. Joe Chávez is representative of the tens of thousands of Chicago Mexicans who have served in the armed forces.

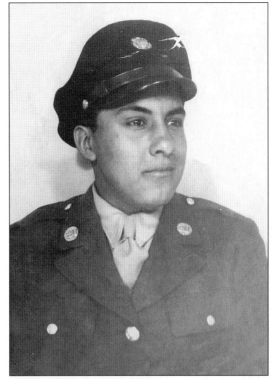

Major Belen Jáquez, a longtime resident of South Chicago, is shown here poised for action at Chanute Air Force Base in 1970. She was the first Mexican to graduate from the South Chicago School of Nursing and later served as a nurse during World War II.

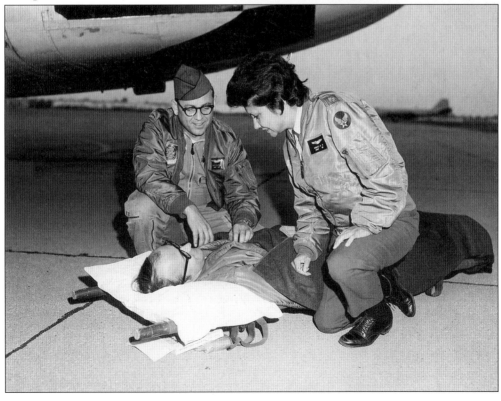

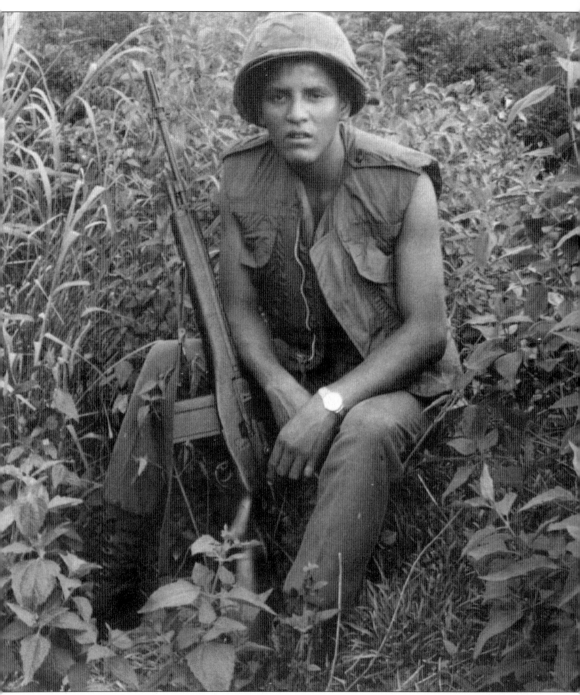

Joe Ramírez, shown here somewhere in Vietnam, was sworn in nine days after his 17th birthday in 1967. He spent time in Cam Ranh Bay, Quin Nhon, and the Phu Tai Valley. He wrote, "after having our Thanksgiving meal, our company was attacked by VC. All hell broke loose, mortar rounds and heavy small arms. . . I set up my M-60 and commenced firing. We suffered 8 casualties. . . . I give thanks every Thanksgiving to the 8 dead soldiers and God, that he watched over me."

90

Originally erected in 1970, this monument honored 12 young men from Our Lady of Guadalupe Parish who were killed in action during the Vietnam War. They are Joseph Quiroz, Antonio Chávez Jr., Edward Cervantes, Ramond Ordoñes, Peter Rodríguez, Alfred Urdiales Jr., Charles Urdiales Jr., Michael S. Miranda, Dennis J. Rodríguez, Leopoldo A. López Jr., Joseph A. Lozano, and Thomas R. Padilla. Pictured here is Carmen Chávez, mother of Antonio Chávez, placing a wreath on the monument. This is the largest number of casualties from one parish for the entire Vietnam War.

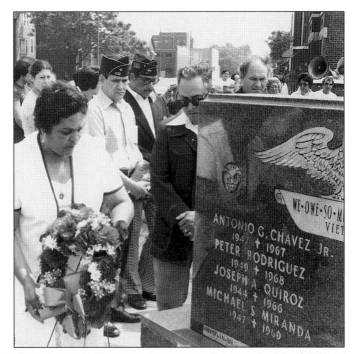

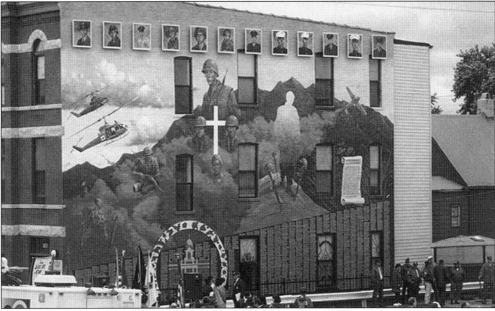

This mural was created to honor Vietnam veterans and memorialize the loss of the 12 servicemen named on the headstone shown above, along with another 27 from South Chicago, South Deering, the East Side, Hegewisch, Lansing, and Calumet City who died during the Vietnam War. Originally painted during the 1970s, it was renovated and rededicated with the help of community residents and veteran's organizations. The mural depicts a jungle fighting scene incorporating reminders of the POW camps and MIA soldiers. It also incorporates a strong reference to Agent Orange. Along the top of the mural located across the street from Our Lady of Guadalupe church are portraits of the 12 young men whose names appear on the headstone of the memorial.

Pictured here are members of the South Deering American Legion Post #1238. Its membership, like that of Manuel Pérez Post, consisted mainly of Mexican-American veterans. It was chartered in 1954. Seated in the front row left are: Raúl Mondragon, Sixto Zaragoza, Ray Arias, Louis Reynoso, Ben Ramírez, Mel Torres; standing in the rear are Sabino "Sub" Sifuentes and Armando Arias.

As members of organizations such as the American Legion, Veterans of Foreign Wars, and G.I. Forum, Mexican veterans worked to protect their interests on local, state, and national levels. They also sponsored athletic teams and developed scholarships to support the education of young people from their communities. Pictured here is Al Galvan, a well-known Mexican-American veteran's rights activist and community leader.

Four

SPIRITUAL LIFE

Mexican spiritual life at its core represents an amalgam of spiritual traditions that reflect our true *mestizo* heritage, a heritage that combines our indigenous and European ancestry. Expressions of this heritage can be seen as much in our artwork as in our unique celebration of *Día de los Muertos*. It can be seen in the talismans we carry, the religious medals we wear, the altars in our homes, and the expressions we use in our daily speech.

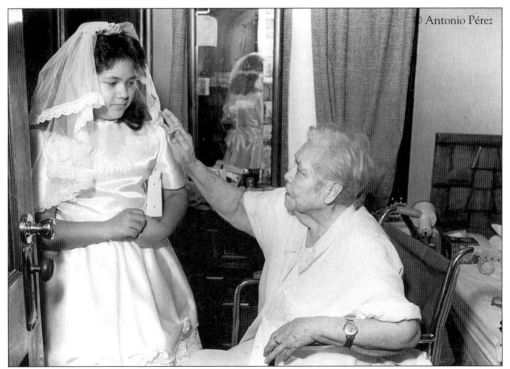

© Antonio Pérez

Doña Isabel Vidales is photographed here in the act of bestowing *la bendición*, the blessing on her granddaughter Marissa Garza. Mexican family tradition gives great reverence to these formal blessings given by grandparents, parents, godparents, and other close family members. A blessing is seen as a way to request God's grace and intercession. The sign of the cross is made on the forehead of the one being blessed.

The Roman Catholic Church has been an important part of Mexican culture since the arrival of Spanish priests to Mexico in the 16th century. It is perhaps ironic that Spanish priests were again involved centuries later in the establishment of ethnic Mexican churches in Chicago. In 1918, concern for the spiritual and religious needs of the growing Mexican community in Chicago prompted a meeting between the Archbishop of Chicago, George Cardinal Mundelein; the Archbishop of Guadalajara, Francisco Orozco y Jimenez; and the Very Rev. D. Zaldivar, C.M.F., the Provincial Superior of the Spanish Claretian Missionaries. At that time, it was decided that the Mexican community of South Chicago was not large enough to merit the establishment of a parish.

According to Our Lady of Guadalupe parish information, American Catholics Mr. P.I. Sullivan and Mrs. Alice B. Bourke wrote letters to the Auxiliary Bishop Edward F. Hoban on behalf of the Mexican Catholics of South Chicago, who had no parish of their own. It should be noted that during this time period, ethnic groups worshiped almost exclusively in their own ethnic parishes. Mexicans faced discrimination from European ethnics who did not want to incorporate them into their parishes. These letters, combined with the voices and petitions of other influential community leaders, highlighted their concern for the spiritual neglect of this community. They also warned about the serious outreach being made by Protestant churches to this community. Cardinal Mundelein granted permission to open a Mexican parish. Following a $12,000 donation from the president of the Illinois Steel Company, Our Lady of Guadalupe Parish was founded in 1923, as a mission church in a frame building at 9024 South Mackinaw. The first pastor was Reverend William T. Kane S.J. The community soon outgrew this small church, and in 1928, a much larger church replaced it as the first Mexican parish to be built in Chicago.

During the summer of 1924, Cardinal Mundelein called upon the Provincial Superior of the Spanish Claretian Missionaries to take charge of Our Lady of Guadalupe Parish and its missionary work throughout the city. After a full Claretian community of missionary priests was formed, 10 different catechetical centers were established in areas throughout the city with Mexican populations. These centers included all of the railroad camps with Mexican residents, as well as a storefront church at 818 West Polk Street. The storefront church provided an opportunity for contact with the pastor of St. Francis of Assisi on Roosevelt Road. "Father Charles Epstein, the pastor at that time, had done a door-to-door survey of this community and had identified a large population of Spanish-speaking people," remembered Father John Enright who served with Fr. Epstein at another parish years later.

In the fall of 1925, Pastor Epstein invited the Claretians to minister to the growing community of Mexicans, and within a short period of time St. Francis became the spiritual center for Mexicans on the west side of the city.

The Missionary Claretians were also responsible for establishing "La Capilla" at 4330 South Ashland to serve the Spanish-speaking population in Back of the Yards, the third-largest Mexican community in Chicago. The Immaculate Heart of Mary Vicariate was opened in 1945, with the help of Rev. Joachim De Prada C.M.F. from St. Francis of Assisi. It was His Eminence Cardinal Stritch who changed the name from "Guadalupe Chapel." These three parishes were for many years the only Mexican Catholic parishes. As neighborhoods changed over the years, parish populations also changed. Increasingly European ethnic parishes saw their Mexican parishioners increase in number. Response to this new group was not always positive; old timers who remember those transitions speak of children being denied admission to parish schools, and Spanish-language masses being relegated to the basement. By 1983, approximately 73 Chicago parishes offered at least one mass in Spanish. Currently, in 2001, the Chicago Archdiocese lists 111 churches throughout the diocese with enough Spanish-speaking parishioners to have at least one Spanish mass. This number could be even higher were it not for a shortage of Spanish-speaking priests.

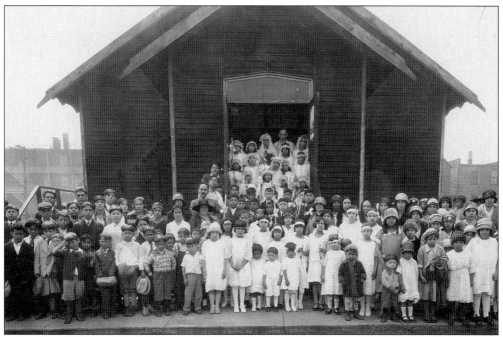

Pictured is the First Communion class in 1927, on the steps of the original Our Lady of Guadalupe Church. The nuns in the photograph are Cordi Marian nuns who arrived in Chicago, fleeing the religious persecution of Mexico's president, Plutarco Elías Calles. They worked as missionaries alongside the Claretians.

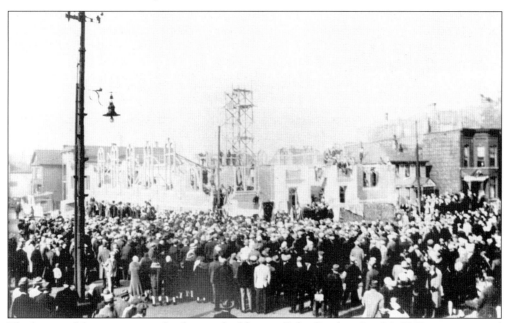

The laying of the cornerstone for the new building on Palm Sunday, April 1, 1928, was witnessed by a huge crowd of people. The exiled Rt. Rev. Pascual Díaz, Bishop of Tabasco, Mexico, blessed the cornerstone in honor of the Blessed Virgin of Guadalupe, Patroness of the Americas. (Photo courtesy of the Southeast Historical Society.)

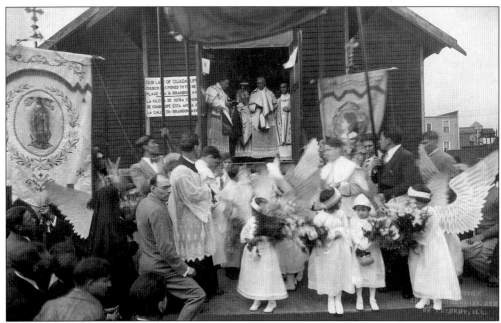

This photograph captures the move from the original frame church built on Mackinaw to the new Classical Revival building on 91st and Brandon. The ceremony was held on September 30, 1928.

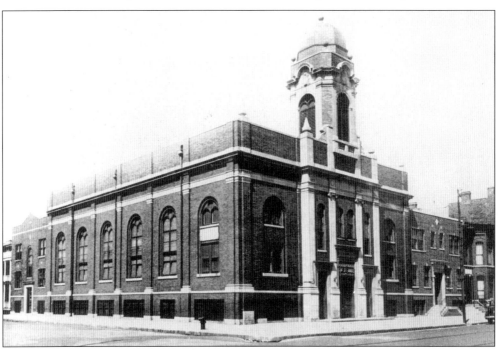

This is the building that replaced the original frame structure of Our Lady of Guadalupe Church. It is a Classical Revival building designed by architect James Burns and built at a cost of approximately $160,000, including the parcel of land. Father Torte, the first pastor, was largely responsible for raising money to help pay off the parish debt. (Photo courtesy of the Southeast Historical Society.)

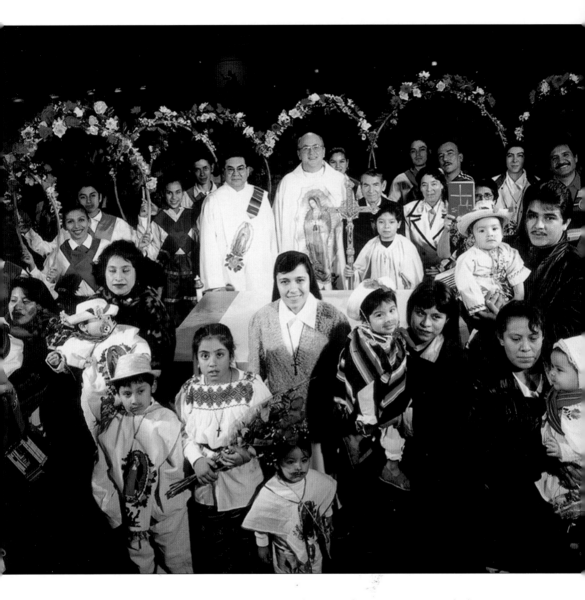

This photograph was used as the front cover in a *Chicago Tribune Magazine* article (January 18, 1998) about the migration of Mexicans from the Mexican state of Michoacán. The late Rev. John Klein is pictured here with parishioners at the celebration of Our Lady of Guadalupe's feast day at Saint Agnes Church in Little Village. There are an estimated 250,000 Mexicans in Chicago from Michoacan. Consequently, if immigrants from Michoacan were counted separately from other Mexicans, they would constitute the second largest Latino group in Chicago. Other Mexican states with a strong presence in Chicago are Guanajuato, Guerrero, Zacatecas, Jalisco, San Luis Potosi, Puebla, Durango, and of course, Mexico City. (Photo courtesy of *The Chicago Tribune*, 2001.)

María Enríquez de Allen achieved national recognition as a folk artist. This Day of the Dead installation at the Mexican Fine Arts Center Museum, done in honor of Maria's deceased husband and child, is an excellent example of her work. Sra. Enríquez's son, Mario Castillo, whose work is profiled in the bottom photo, was the catalyst for the Pilsen Mural Movement.

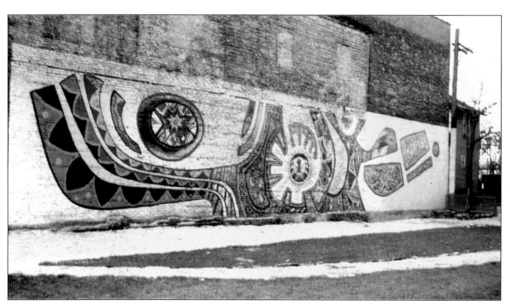

Mario Castillo's mural *Metaphysics*, painted at 1935 South Halsted in 1968, launched the Pilsen Mexican Mural Movement. Unfortunately, this mural was later destroyed. The murals created by Pilsen artists inspired artists across the city to literally take to the streets and paint murals.

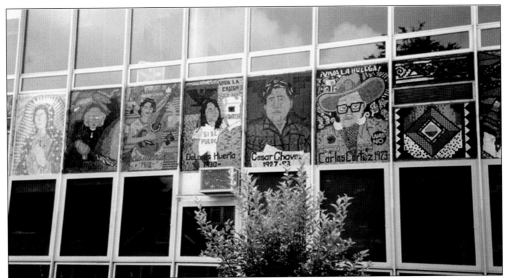

The mosaic-tile mural on the entrance of the José Clemente Orozco Academy in Pilsen has attracted numerous visitors. Shown here is a section of the almost one-half-block mural. The mural was done by Orozco art teacher Francisco Mendoza and students over a period of almost 10 years, in a project sponsored by the Mexican Fine Arts Center Museum. After the new Orozco Academy was built in the fall of 2000, the old Orozco School became part of Cooper School.

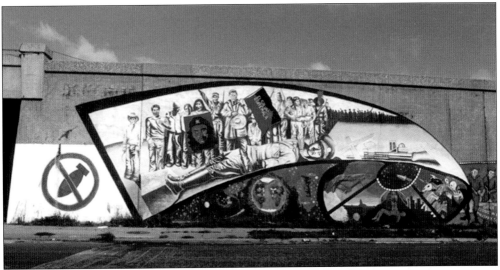

This mural entitled *Prevent World War III* was an interesting collaboration between some of Pilsen's Mexican artists and other city artists. The Mexican artists that worked in this project were Marcos Raya, Carlos Córtez, José Guerrero, Román Villarreal, and Rey Vásquez.

MEXICO:LA VISION DEL COSMOS
Three Thousand Years of Creativity

© Kathleen Culbert-Aguilar

© Kathleen Culbert-Aguilar

The Mexican Fine Arts Center Museum has earned national praise for its exhibitions, performing arts festivals, art collection, education programs, Radio Arte WRTE 90.5 FM—its youth-run radio station—and its Yollocalli Youth Museum. Pictured is a gallery shot of the exhibition, *La Visión de los Cosmos*. This 1992 exhibition marked the first time that artwork from ancient Mexico had ever been exhibited in a Mexican community in the U.S.

In 1997, as part of their 10th anniversary celebration, the Mexican Fine Arts Center Museum presented the exhibition, *La Reina de las Américas*. This exhibition featured artwork from the museum of Mexico's holiest shrine, the Basilica of the Virgen de Guadalupe. This exhibition was a huge success for the museum.

César Chávez is shown signing Carlos Córtez's print of César Chávez at the Mexican Fine Arts Center Museum in 1993. The strong non-violence beliefs shared by both of these individuals have been universally recognized. Chávez's appearance at the museum was his last speaking engagement in the Mexican community. A week later, Chávez passed away. Córtez is a long-time union activist, graphic artist, and poet. Córtez, in short, is a Chicago treasure.

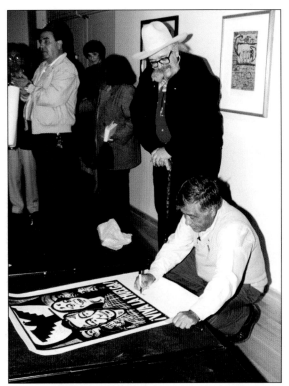

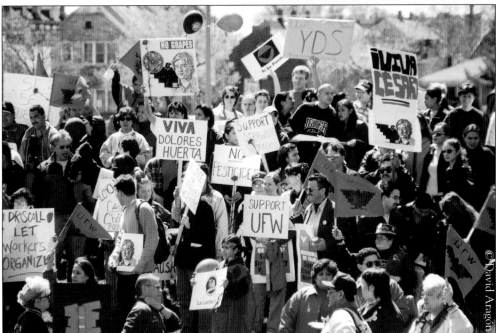

A large crowd gathered in 1993 at Pilsen's Harrison Park soon after César Chávez's death to pay homage to him and his cause. Although Chicago is an industrial city, Chávez's movement to provide better pay and working conditions for farm workers through a strategy of nonviolent protest attracted many supporters in Chicago.

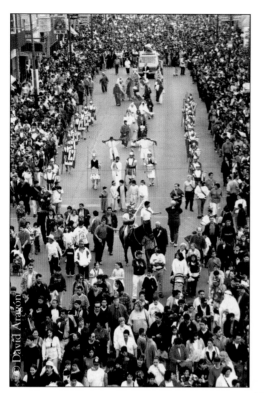

Every year, thousands of people participate in Pilsen's annual Good Friday procession. The march, organized by several Catholic churches in the community, makes its way down 18th Street until it reaches Harrison Park. As the procession nears Harrison Park, more and more individuals join in the procession. Once inside the park, three community residents—representing Jesus Christ and the two criminals who were crucified with Him—are tied to crosses on a small hill in the park. This very spiritual and touching retelling of the passion story has become one of Chicago's best known annual rituals.

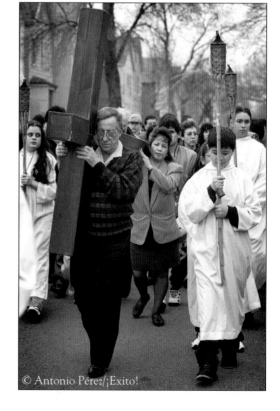

While Pilsen's annual Good Friday procession and reenactment attracts citywide attention, the Mexican community of Holy Cross Church in Back of the Yards also stages a very beautiful and touching Good Friday procession.

© Antonio Pérez/¡Exito!

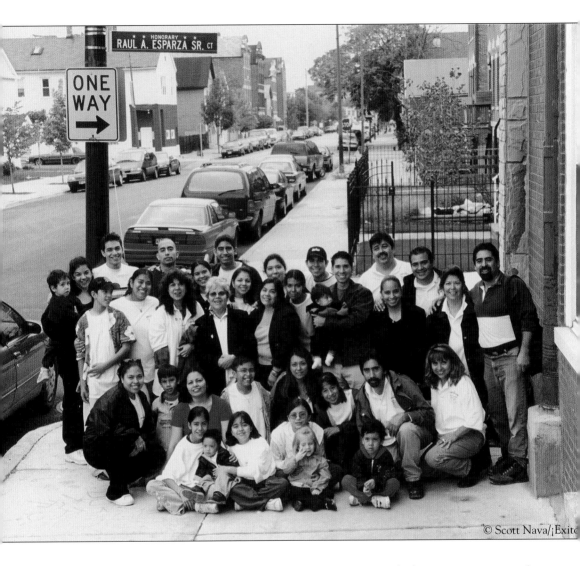

© Scott Nava/¡Exito

The Esparza family of Pilsen is gathered here in a family portrait at the honorary street named for Raúl Esparza Arellano Court. In a very tragic fire in the family's home in the year 2000, Raúl's son, Jaime, heroically saved his mother from the fire, but in attempting to rescue his father, they both succumbed to the smoke. This very close, religious, community-minded, and hard-working family exemplifies the best of the Mexican community.

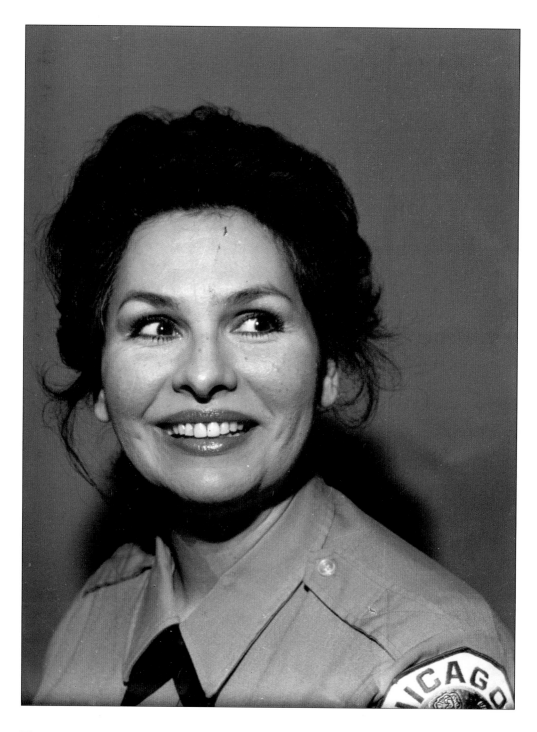

This portrait is of Irma Ruíz, the first Mexican female Chicago police officer to be killed in the line of duty on September 22, 1988, at Montefiore School. She was honored for her heroism when a Chicago Public school was named for her.

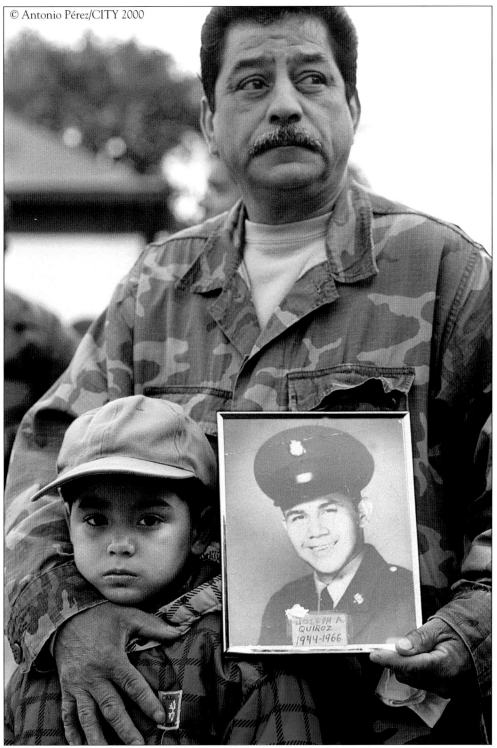

Gilbert Rodríguez, accompanied by his son Felipe, holds a picture of his deceased cousin Joseph A. Quiroz at the rededication of the South Chicago Vietnam Veterans Mural on August 24th, 2000.

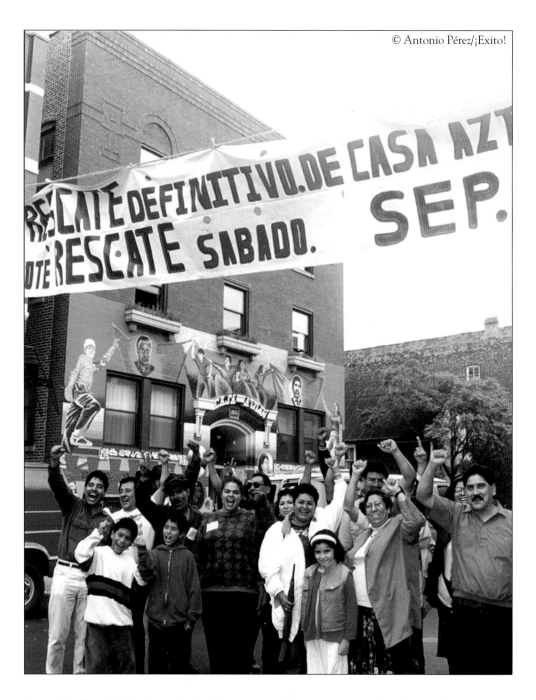

Since the late 1960s, Casa Aztlan has organized Mexicans around such social concerns as immigration, workers' rights, and political issues impacting Mexicans both here and in Mexico. Executive Director Carlos Arango (second from the left) and others stand in front of the famous mural on the facade of Casa Aztlan. This mural, painted by Marcos Raya, Salvador Vega, and Carlos "Moth" Barrera, has become one of Chicago's best-known public art works.

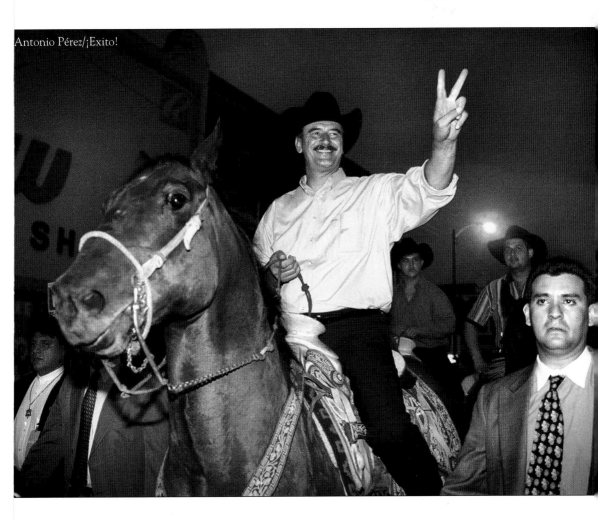

The importance of the Mexican community in the U.S. is best illustrated by Vicente Fox's visit to Little Village during the presidential campaign of 2000. Fox would later win the election. Mexican nationals in Chicago have long advocated for the right to vote in Mexico's elections, but to no avail. In a mock election held in Chicago, Fox won in a landslide.

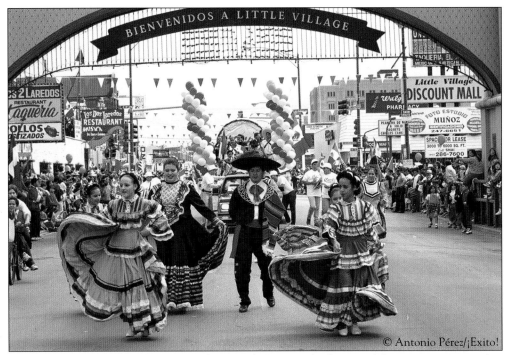

© Antonio Pérez/¡Exito!

The Mexican Independence Day Parade on 26th Street is the largest of the community parades. The arch on 26th Street near Albany serves as a welcoming beacon for all visitors to Little Village. From the arch to Kostner and 26th Street is a stretch of nearly 2 miles, consisting of primarily Mexican businesses. After Michigan Avenue, 26th Street is the city's second largest generator of sales tax. This area is a clear example of Mexican economic power.

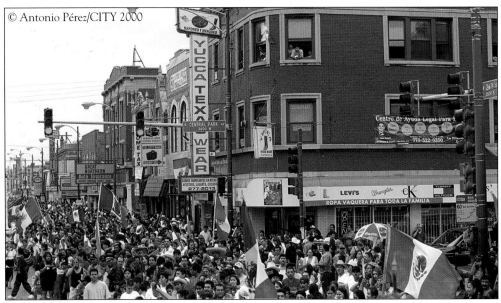

© Antonio Pérez/CITY 2000

A throng of people are shown celebrating Mexican Independence Day in Little Village. In the 1960s, Mexicans began moving into this neighborhood in large numbers. Today, Little Village has become the largest Mexican community in the Midwest.

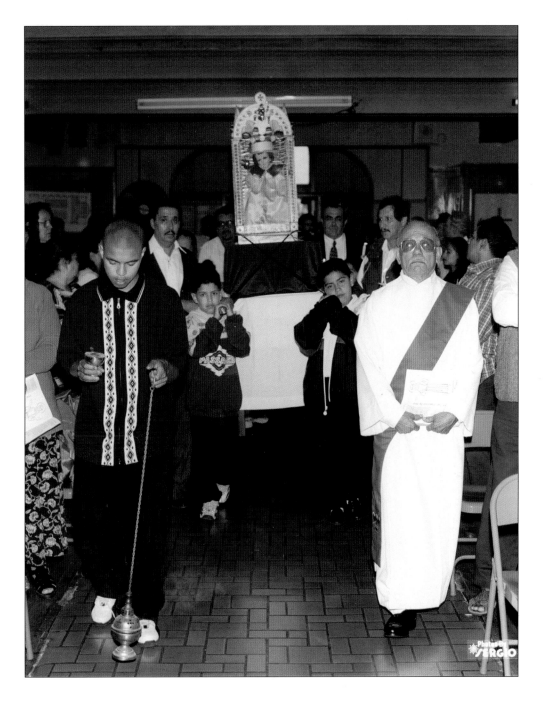

This September 21, 1997, photograph depicts the installation and blessing ceremony of "El Santo Niño de Atocha" from Plateros, Zacatecas, Mexico. This saint is extremely revered in Mexico, where it is very common for each parish, or *parroquia*, to have patron saints. El Santo Niño de Atocha can be found at St. Francis Church.

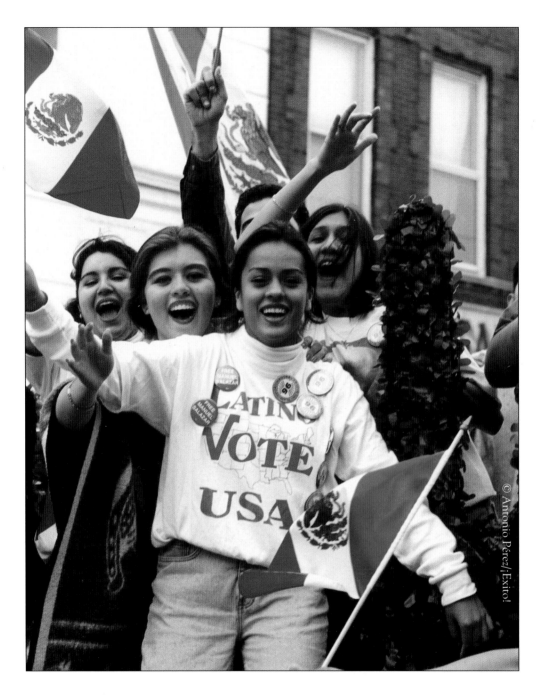

© Antonio Pérez/¡Exito!

Throughout the 1990s and into the new century, numerous pan-Latino efforts to get people naturalized, registered, and to the polls were intensified. In spite of these efforts, Mexicans still voted in lower rates by percentage than the African-American and European-American communities. Hopefully, these young Mexicans will positively change these numbers in the future.

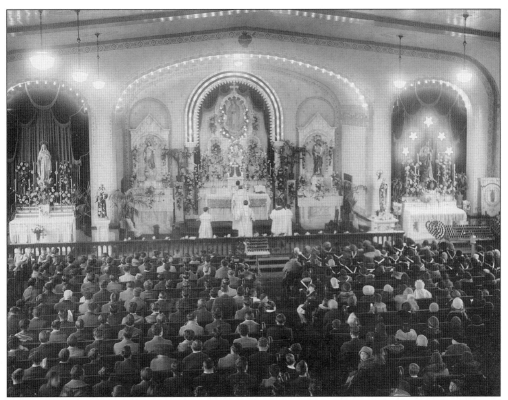

Taken from the choir loft, this photograph is the first mass performed in the new Our Lady of Guadalupe Church. The interior of the church reflects Pre-Vatican II traditions that include a communion rail, priests concelebrating mass with their backs to the parishioners, and an elaborate front altar.

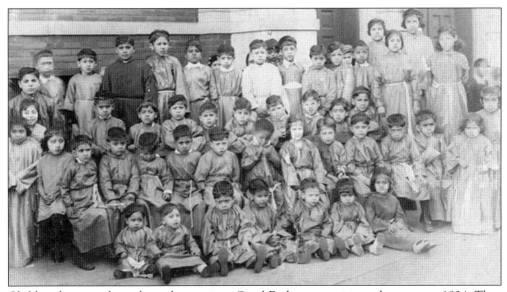

Children here are dressed to take part in a Good Friday procession and pageant *c.* 1934. They are all wearing robes and facsimiles of the crown of thorns.

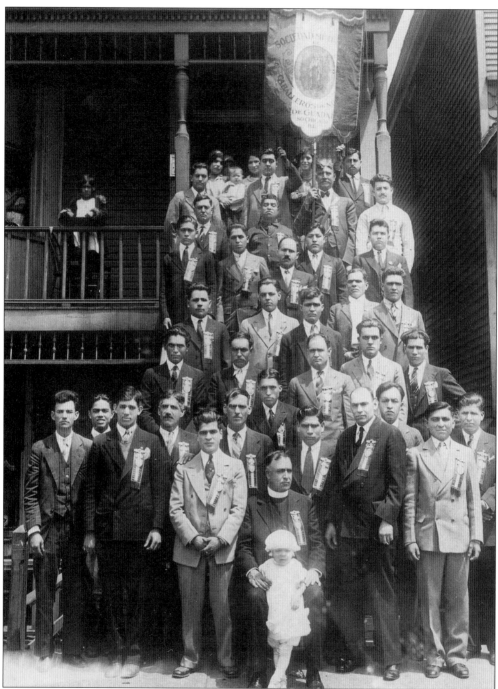

Mexican Aide Society members paid dues of 10¢ a month. Their principle concerns were the support of catechism for children and adults, as well as works of charity for destitute Mexican parishioners. The group called themselves Los Caballeros de Nuestra Señora de Guadalupe. The group was started by Father Torte. Included in this group shot are Mr. Torres, Mr. García, Leandro de la Cerda, Goyo Mendoza, Augie Mendoza, Severino López, Bob López, Juan Ruíz, and Máximo Páramo.

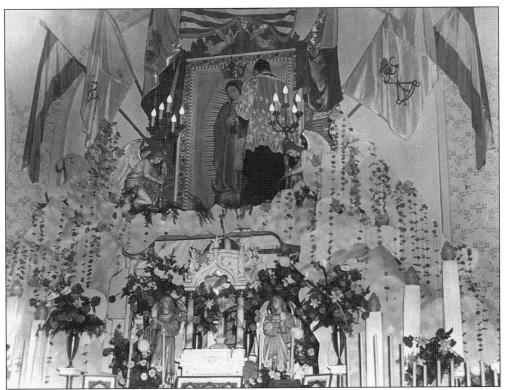

Father Catalina is photographed here placing a crown over the image of the Virgin of Guadalupe that hangs over the central altar. The crown is a replica, fashioned like the one sent to Mexico by the Pope to be placed over the image of the Virgin at the National Cathedral in Mexico City.

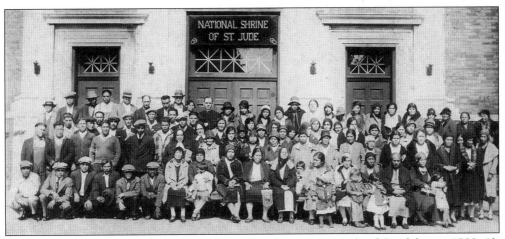

Father Torte and early parishioners are pictured in front of Our Lady of Guadalupe c. 1939–40. "My mother, Rusina Garcia, is sitting in the front row with the beaded bag. She and many others donated money to pay for bricks to help build the church," remembered Carmen Mendoza. The church continues to be the nucleus of family and community life in South Chicago. Its parishioners include recent arrivals to Chicago as well as members of families with a long history in South Chicago. There are increasing numbers of parishioners who no longer reside in the surrounding community, but return to attend mass every Sunday.

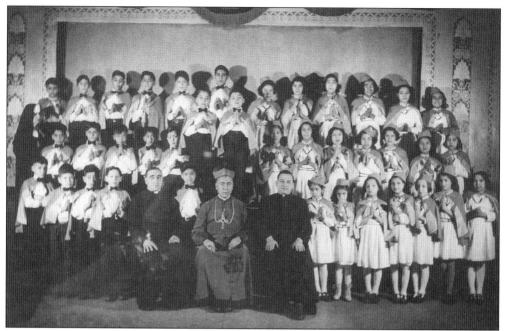

Members of the Our Lady of Guadalupe Children's society posed with clergy in the church auditorium *c.* 1939.

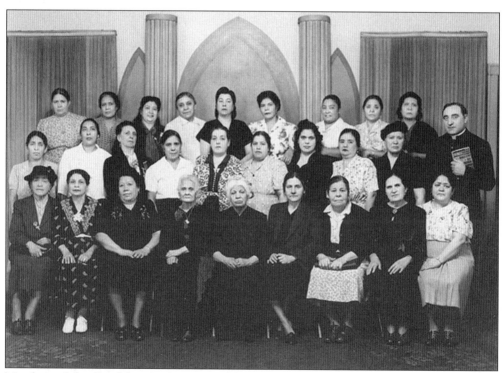

Members of the Guadalupana Society are photographed here, *c.* 1947, with Father Catalina. The women in the photograph worked hard for the parish. This group includes Mrs. Aguilera, Aurora Guzmán, Ramona Carrillo, Jacinta Mendoza, Mrs. Martínez and Mrs. Ruíz.

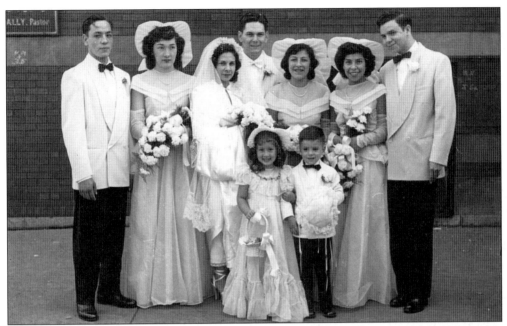

This photo shows the June 4, 1949, wedding of Carmen Martínez and Raymond Arias. They were married at St. Kevin Church in South Deering. St. Kevin was established in 1885 to minister to a predominantly Irish community. At the time of this photograph, the parish was receiving more Mexican parishioners. Before this time, many community residents traveled to South Chicago to worship at Our Lady of Guadalupe because they were not welcomed into European ethnic parishes. The groomsmen are Alex Casteñeda and Carmen Torres. The bridesmaids are Amy Arias, Olga Martínez, and María Ofelia Martínez. The flower girl is Margie Reyna, and the ring bearer is Adalberto González.

This photograph was taken at St. Anthony of Padua Church in Roseland, another ethnic parish to undergo change. The parish was built by Italian Catholics. Just as Mexican families gradually entered other Italian parishes such as St. Francis of Assisi on the west side, they were assimilated into parish life here. The bride and groom, Oscar Hinojosa and Suzie Lebrón Hinojosa, are facing the original altar and are encircled by the traditional Mexican wedding *lazo*. This wedding took place October 23, 1999.

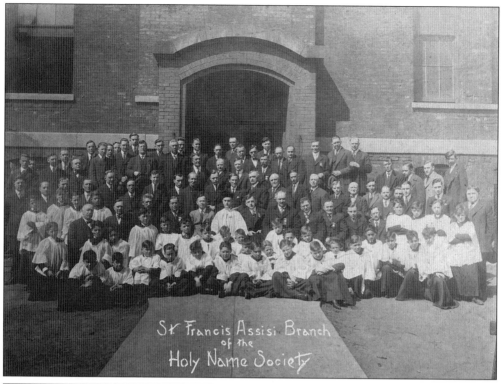

St Francis Assisi Branch
of the
Holy Name Society

Captured in this photograph, taken of the Holy Name Society of St. Francis of Assisi on Easter Sunday in 1922, is evidence of a changing parish population. The presence of Mexican altar servers indicates that Mexican families were joining the primarily Italian parish.

This photograph, taken from the back of the church, shows the mechanism used to move St. Francis of Assisi when it became necessary to widen Roosevelt Road in 1917. Founded in 1853 to serve a primarily German community, its membership was changing as the surrounding community became increasingly Italian. Saint Francis parishioners have been predominantly Mexican since the early 1930s.

By the date of this wedding in June of 1945, the missionary outreach of the Claretians from Our Lady of Guadalupe parish in South Chicago had proven to be hugely successful. This couple, Rosita and Marciano Pérez, represent thousands of Mexican parishioners who were members of the St. Francis of Assisi parish community.

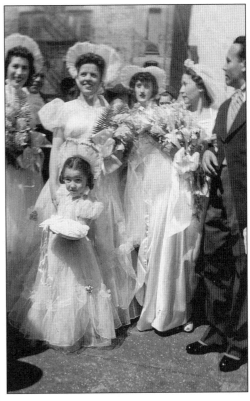

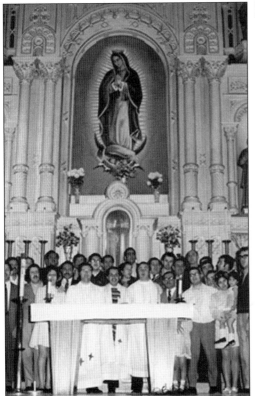

This photograph, taken on the main altar at St. Francis of Assisi in the early 1970s, shows the first mass of Spanish-speaking deacons ordained by the Archdiocese. They are shown here with their wives. The young priest in the photograph, Arturo Pérez, had just been ordained as a diocesan priest. In spite of the huge numbers of Mexican Catholics in Chicago, Fr. Pérez remarked, "I was only the fourth Mexican priest ordained as a diocesan priest up until that time."

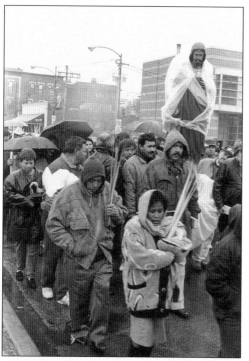

In September of 1994, the parishioners of St. Francis protested the archdiocesan decision to close their 3,000-member financially solvent parish and consolidate it with the neighboring Holy Family Church. This decision reflected a basic lack of understanding of the strength of a parish community that exists outside of community borders.

The images on this stained-glass window installed in the renovated St. Francis of Assisi Church document and celebrate the successful struggle of parishioners to keep their parish open in spite of the Diocesan decision to close it.

FEB 4, 1996

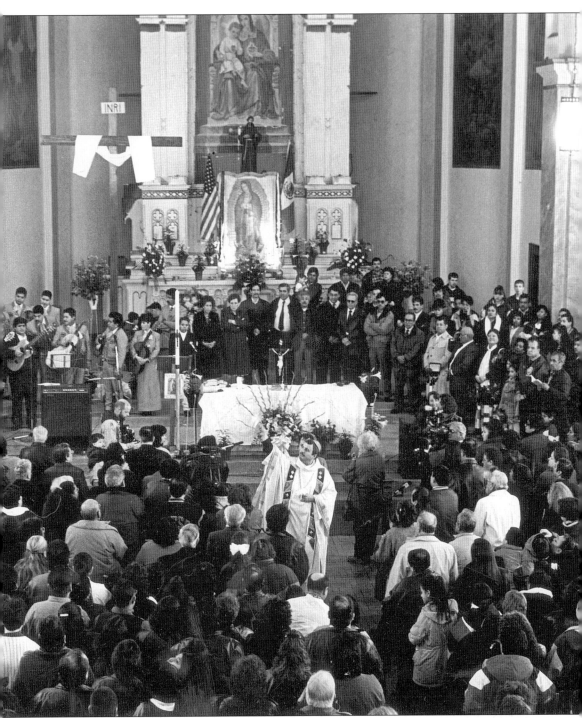

After a two-year battle between parishioners and church officials, St. Francis of Assisi Church reopened officially on Easter Sunday 1996; Bishop John Manz officiated. In his homily, he said in Spanish to the overflowing assembly, "Perhaps God changed their minds," as he spoke of Cardinal Bernadin's change of heart.

Children of Old Mexico Open Holy Week

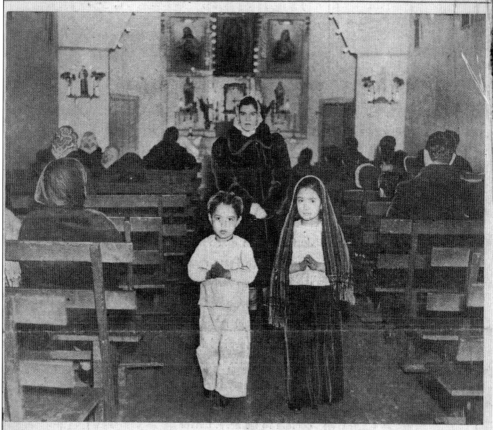

Lucia Moyado and her little brother, Manuel, walk up the aisle of Our Lady of Guadelupe chapel, 4330 South Ashland avenue, in solemn observance of the opening of Holy week. Mrs. Juana Chico, 4508 South Laflin street, follows the children away from the altar which is made from an old ice box. Our Lady of Guadelupe chapel has a membership of Mexicans who reside back of the yards. Men of the church made the benches, and all of the altar and church decorations were painted by members. [TRIBUNE Photo.]

When Miss Mary Louise Garibay, 1543 West 46th street, was asked for a description of Palm Sunday services at Our Lady of Guadelupe chapel, 4330 South Ashland avenue, she responded with the following letter, a composition which seemed complete. Miss Garibay started the study of English when she came to Chicago when 17 years old. She is in her early twenties and has realized her ambition "to speak without a foreign accent."

"What can I say about Palm Sunday? You expect something extraordinary and shall get something very usual.

"Palm Sunday we have blessing and distributions of palms. There is to be a high mass. Our choir, consisting of three girls and the sister who plays the organ, will sing the mass. Does it sound too simple? I assure you the simplicity will add to its beauty and worth.

"We have our missions in Lent. Ours was just completed. Father Augustine Leal preached a one week general mission. It was very inspiring.

"Our financial campaign is progressing rather well. We have gotten donations even from people of other nationalities.

"The first dance sponsored by the committee was a great success. Plans are being made for the next one, April 20, to be in South Chicago. The pastor of Our Lady of Guadalupe church, Father Antonio Catalina, has generously consented to give us the use of their hall for this occasion."

This clipping from an old copy of *The Chicago Tribune* documents the community connections between the Back of the Yards community and the South Chicago community.

Immaculate Heart of Mary storefront church at 4330 South Ashland had early connections to the priests and parish community of both Our Lady of Guadalupe and St. Francis of Assisi. It opened as *La Capilla* in 1945, but it wasn't until several years later that it opened as a Vicariate.

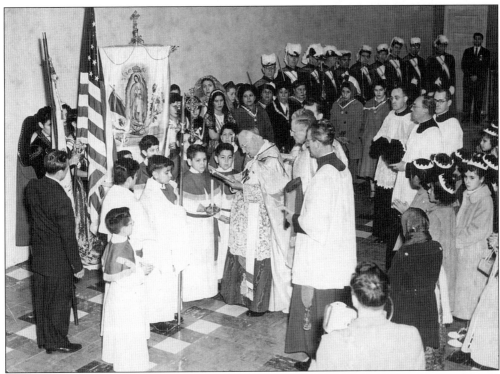

This photograph shows the dedication of the Youth Center at Immaculate Heart of Mary. Officiating is His Eminence Joseph Cardinal Stritch in 1957. They are assembled in front of a banner of Our Lady of Guadalupe.

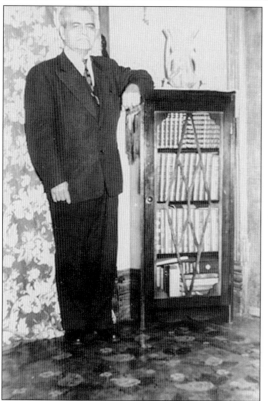

Although predominantly Catholic, there are a growing number of Mexicans who are members of Protestant churches. This photograph was taken on Easter Sunday 1987, of sunrise services for a South Chicago Protestant group in Calumet Park on the shore of Lake Michigan.

The gentleman in this photograph, Claudio Salmerón, was a Pentecostal minister. Historically, all of the major denominations were represented in the Mexican colonias as early as the 1920s.

Children from Epiphany Parish in Little Village are shown participating in a 1984 Christmas pageant.

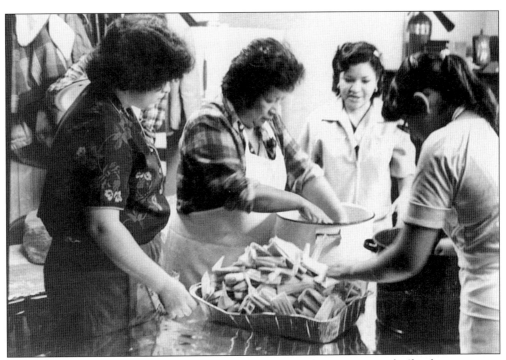

Women parishioners from Epiphany are shown getting ready to serve tamales for the retirement celebration of their much loved Pastor Father John Enright.

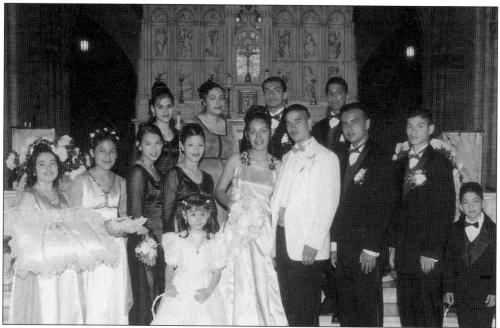

Mexican girls often celebrate their 15th birthday with a church ceremony in which they accept their responsibilities as young adult members of the church community. The celebrations often become very elaborate with attendants, male escorts, and a big party following the church ceremony. In this picture, Maritza Luna and her escort, Felipe Medina, are surrounded by friends acting as her *damas* (female attendants) and *chambelanes* (male escorts) on the altar at St. Paul Church in Pilsen, June 19, 1999.

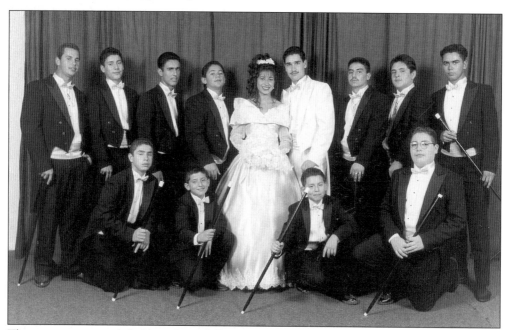

This quinceañera was held at St. Adalbert's Church in July of 1993. The *chambelanes* are dressed formally in tails. Nancy Guzmán and her escort are standing in the center.

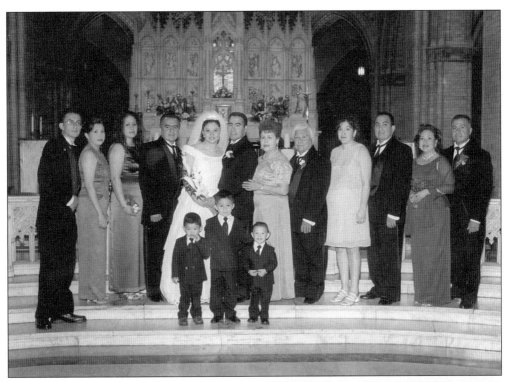

St. Paul's Church in Pilsen was the site of the wedding of Raquel Aguiñaga-Martínez and Raúl Alberto Martínez in 2000. They are shown surrounded here by their family. Pictured, from left to right, are: Luís Corral, Adriana Isabel Corral, Andrea María Martínez, Eduardo Javier Martínez, bride and groom, Ana María Martínez, Inocencio Martínez, Rocío Martínez, Alejandro Juan Martínez, Martha Guadalupe Martínez, Carlos Inocencio Martínez, Nicolás José Martínez, Eduardo Gabriel Martínez, and Luis Alberto Corral.

Plácido Rodríguez came to Chicago from Celaya, Guanajuato. He studied at St. Francis of Assisi parish school, where he was introduced to *los Claretanos*, the Claretians. Ordained a Claretian priest in 1968, he was assigned as an associate pastor at Our Lady of Guadalupe Church in South Chicago, where he worked until 1975. Named an auxiliary bishop of Chicago in 1983, he is the first North American Claretian bishop and the first Mexican American bishop for the Archdiocese of Chicago. On April 5, 1994, he was chosen to serve as Bishop of Lubbock, Texas.

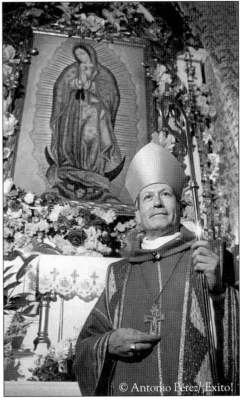

© Antonio Pérez/¡Exito!

When some Mexican leaders found out that the Pope's 1979 itinerary in Chicago did not include a visit to the Mexican community, they voiced their concerns. Consequently, the Pope's schedule was adjusted. Providence of God Church, located right off the Dan Ryan Expressway in Pilsen, was selected as the parish that the Pope would visit. This appearance at Providence of God was attended by thousands.

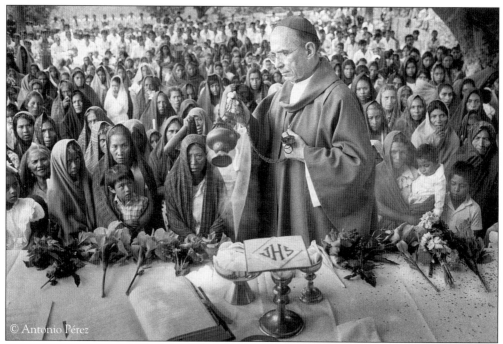

Joseph Cardinal Bernadin is pictured here saying mass at the Quechultenango Mission, Diocese of Chilpancingo in Guerrero, Mexico. This is one of the many partnerships with Mexico that have been made by the Chicago Archdiocese.

Five

WORK

The original Mexican neighborhoods in Chicago developed around work sites, near steel mills, factories, railroad yards, and stockyards. As unskilled and semi-skilled Mexican immigrants arrived in the Midwest in the early 1900s, they entered a labor market with multiple work opportunities. Their presence in all sectors of that labor market and their contributions both to Mexico and the United States was and continues to be a complex international and transnational issue. The United States government reaped benefits from government actions that took advantage of an almost inexhaustible labor source. Mexico was able to "export" unemployed workers and disenfranchised *campesinos*. It also gained a source of income as "migradollars" were sent home by Mexican nationals working in the United States.

The cycle of immigration was repeated in subsequent decades. Each new decade reflected the political and economic realities of both countries. During times of depression, as in 1921 and again in the late '20s and early '30s, immigration slowed and many Mexican workers left the Chicago area. Some were repatriated either "voluntarily" or through various forced repatriation efforts. During this time, the Chicago and Calumet area Mexican colonias lost many residents, including legal residents, citizens, and others whose children had been born in the U.S.

The 1940s brought new demands for labor, and the United States government responded with emergency war time measures, including the Bracero Labor Agreement of 1942. This program allowed the U.S. government to regulate the recruitment of workers from Mexico. This agreement was not fully terminated until 1964. The 1950s and the Korean War revived bracero guest worker agreements.

The cycle of immigration is still being repeated, with new immigrants both official and undocumented continuing to arrive to Mexican communities throughout Chicago and the Midwest. New arrivals with limited skills and limited English usually enter jobs not unlike those available to immigrants in the early 1900s. Landscaping work often replaced migrant farm work, and non-union factory work replaced the unionized jobs in steel and other heavy industries of earlier decades. Not all new arrivals belong to this category, just as not all new arrivals are from predominantly rural areas. The number of immigrants from urban areas has increased, and among them are more skilled workers, clerical workers, professionals, and business men.

The workers portrayed in the photographs included in this chapter reflect our diverse work experiences. We are commonly portrayed as laborers, and yet we are present in Chicago in all careers and occupations. We are artists, teachers, lawyers, students, food service workers, doctors, labor leaders, and business owners. We work in government service and private enterprise. We speak English, Spanish, and combinations of both. Our diversity is at the same time a resource and a challenge. The workplace of the 21st century is where the future of our communities will be written. That future demands the resolution of important work-related immigration issues, issues of equity in the work place, access to education, and job training.

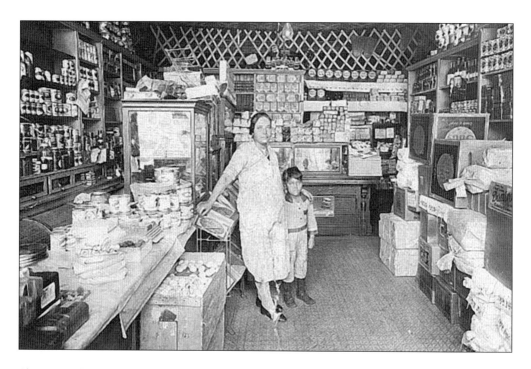

Shown in the top photograph is the Hernández family grocery store. It was located at 1100 South Peoria Street in 1921. Below is a 1927 photograph of the first Mexican pharmacy in South Chicago. Shown in the photograph are Mr. Galindo and Frances Martínez.

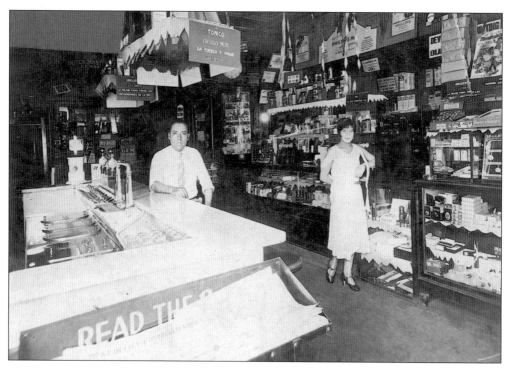

Joe López and A. Bianchi became partners in a Universal Auto Repair and Shell Service station. The station was founded in 1926, and was eventually purchased by Joe López.

Joe López is pictured working on a car in his South Chicago shop, c. 1937.

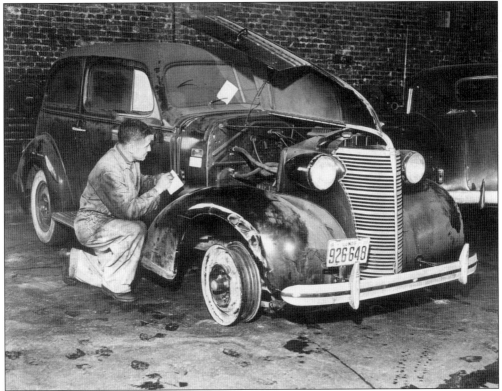

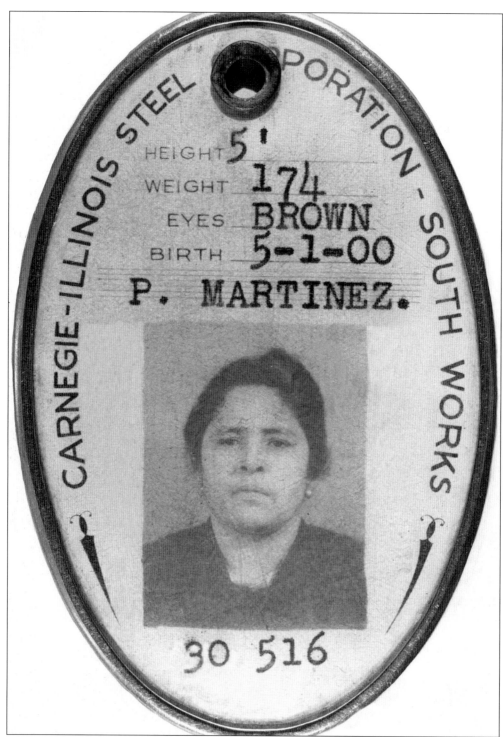

This identification tag was used by Pasquala Martínez, who worked for Carnegie Steel Corporation in the 1940s. She worked as an oiler in the roundhouse and was lovingly called *Rosita the Riveter* by her daughters. (Photo courtesy of the Southeast Historical Society.)

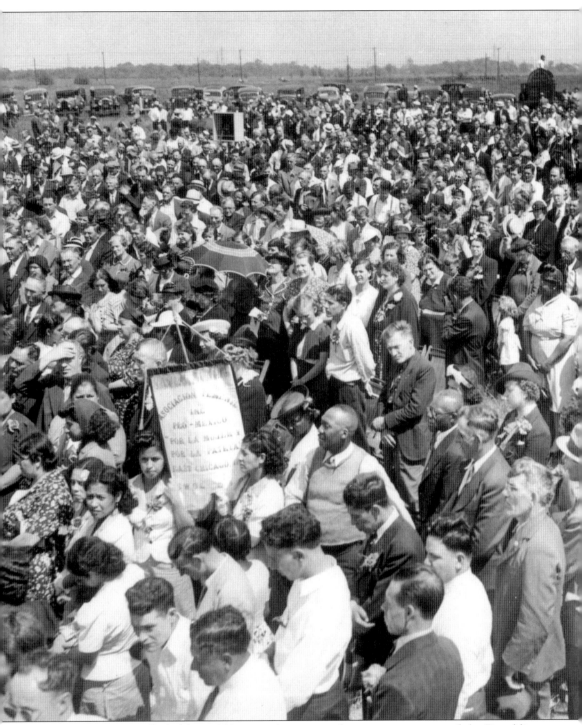

Pictured is a mass rally held in 1939 to commemorate the massacre victims of the Republic Steel Strike of 1919. Labor groups from all over the city and state were in attendance. Pictured in the foreground under their banner is a Pro-Mexico group showing their support. (Photo courtesy of the Southeast Historical Society.)

Mexican packing-house workers are photographed at a meeting in 1938. Many of the residents of the Back of the Yards neighborhood worked in the packing houses or in related jobs in the stock yards and food processing plants. (Photo courtesy of the Chicago Historical Society.)

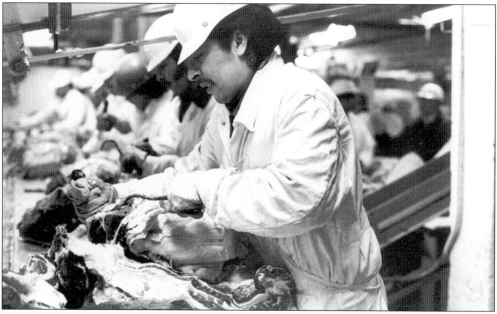

Photographed here is a Mexican packing-house worker processing meat in 1975. (Photo courtesy of the Chicago Historical Society.)

Tomasina Mendoza graduated as a registered nurse from Columbus School of Nursing c. 1941. She worked at Marcy Center.

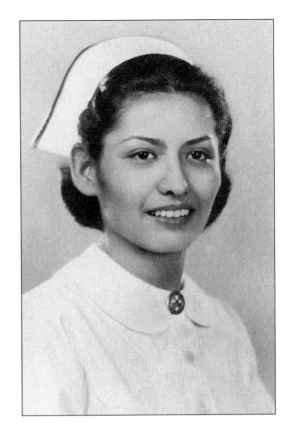

Pictured is Teresa de la Cerda in front of La Rosa de Oro market in South Chicago c. 1925. Many small shop-owners served the Mexican communities.

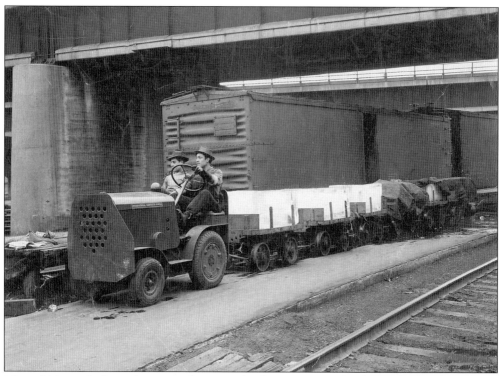

Manuel Monreal, shown here seated next to the driver, moving freight in a railroad yard.

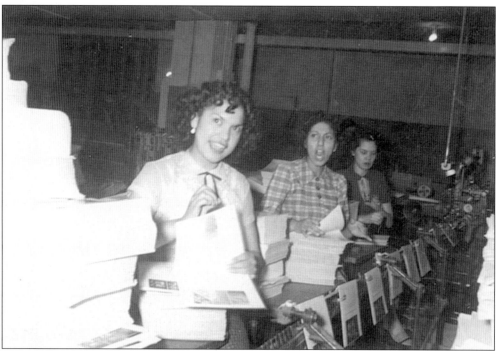

Julia Muñoz and friend are photographed here sometime in the late 1940s at Poole Brothers and Company doing book binding. The firm was located at Clark and Harrison in Printers Row.

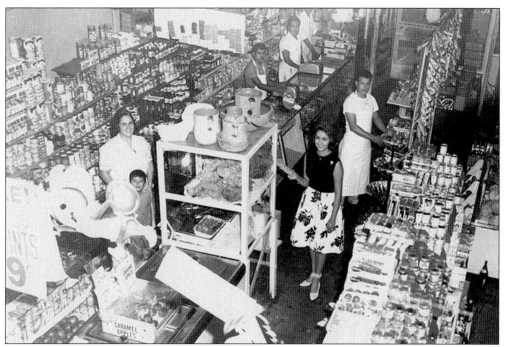

This is a panoramic view of El Esfuerzo store located on Polk and May. It was owned and operated by the Bautista family, some of whom are pictured here.

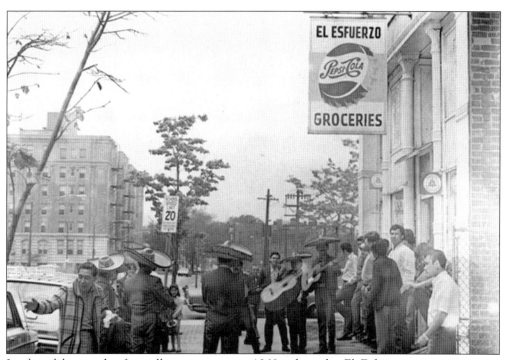

La despedida was the farewell party given in 1968, when the El Esfuerzo grocery store was relocated to 18th Street because of the development of the University of Illinois Chicago campus.

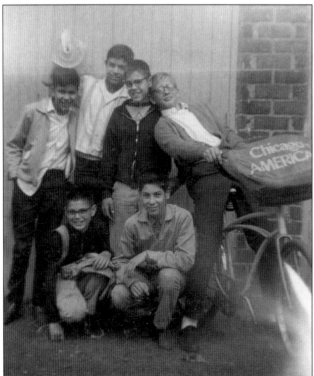

Eddie Peralta, a well-known businessman and community leader, is pictured in front of his store known as the Marylou. The store was located at 3212 East 91st Street. It closed in 1978.

Mexican newspaper boys and friend, shown here after their routes, delivered the *Chicago American Newspaper*. This photograph, taken in the early 1960s, shows them near Watson's News Agency in South Deering. Included in the photograph, standing left to right, are: Tom Torres, Ray Arias, David Nunke, Al Arias, and Javier Martínez. Ray Arias would much later run a credible but unsuccessful campaign for Congress in the 2nd Congressional district against Gus Savage.

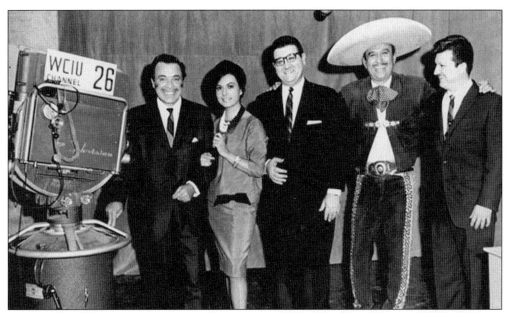

Documented by this photograph is the first television program in Spanish presented in February of 1964. Those on hand include German Valdez (Tin-Tan), unidentified woman, José Chapa, Angel Infante, and Ramiro Marroquia. Channel 26 was the first television station to offer Spanish language broadcasting. Chapa, a long-time proponent of dual nationality, became the first Mexican in Chicago to receive dual nationality, which was approved during President of Mexico Ernesto Zedillo's administration. Chapa paved the way for other Mexican broadcasters such as Teresa Gutierrez, John Quiñones, Jim Avila, Phil Ponce, and Peter Nuno to name a few who would become successful reporters on mainstream television.

Henry Bellagamba—native of Monterrey, Mexico—worked at WSBC radio as a Spanish-language announcer from the early 1950s until 1978. He also worked as a host of WCIU Channel 26. One of his favorite phrases was the following Spanish/English *dicho*, "si drinking, no driving" which became his trademark.

The Ford Automobile plant at 130th Street and Torrence Avenue is the site of the assembly line pictured here. It was one of the many industrial job sites where men from the surrounding communities worked.

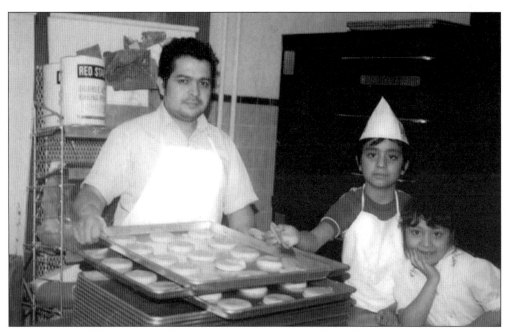

Pictured in a 1980s photo are Jorge Pérez Sr. with his children Gabriela and Jorge Jr. in his *panadería*—Cristy's Grocery and Bakery. The bakery is located on 83rd Street near Sullivan School. On the trays are pan dulce waiting to be put into the ovens.

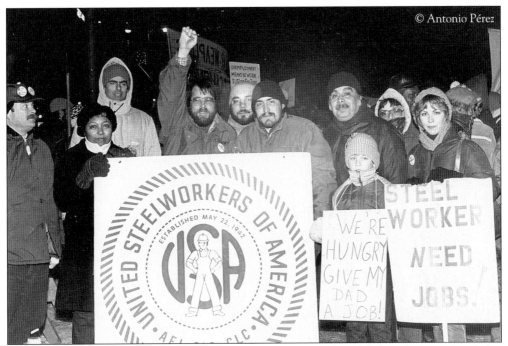

Mexican steel workers were part of the United Steelworkers of America Union AFL-CIO Local 65 shown here on strike.

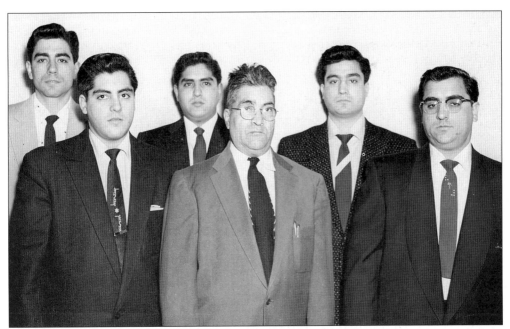

The Valadez family, photographed here for a magazine article, were all involved in organizing workers in the steel industry. Shown here with their father, these five brothers grew up in South Chicago and worked at U.S. Steel. The brothers were also the first Mexican apprentices in training programs for pipe fitters, carpenters, bricklayers, and machinists. Pictured, from left to right, are: Lee, Lupe, Frank, Gerado, Benny, and Sacramento.

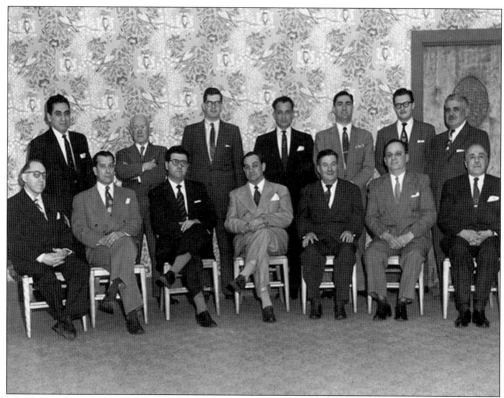

The members of the first Mexican Chamber of Commerce in Chicago are pictured here. Seated are: architect Carlos Magro, Miguel Wimer, José Chapa (secretary), General Consul of Mexico Raúl Michel, Abraham Gómez, Ruben Cárdenas, Luis Moya, and Vicente Garza.

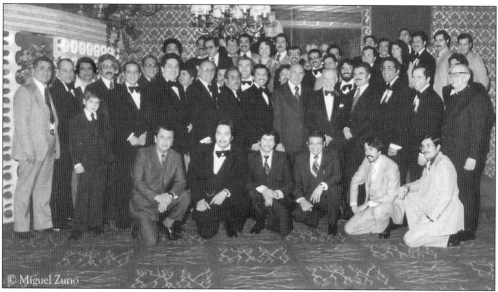

Members of the Mexican Police Officers Association pose here in the 1970s.

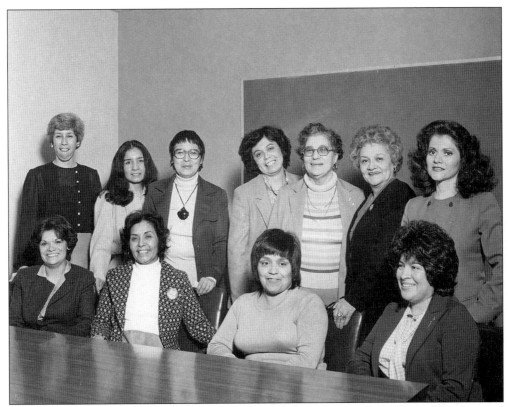

The women in this 1980 photograph are part of the Mexican Business and Professional Women's Association. They include, top row, left to right: Marilyn Salazar, Virginia Martínez, Irene Flores, two unidentified members, Irene Hernández, and Teresa Gutierrez. Seated in the middle of the front row are Rhea Mojica Hammer and Carmen Velásquez.

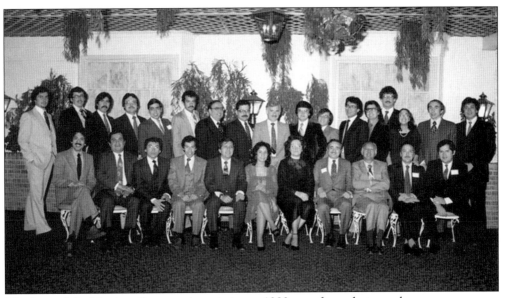

Members of the Mexican Lawyers Association c. 1980 pose for a photograph.

© Antonio Pérez/¡Exito!

Standing in his court room wearing his judicial robes is Judge David Cerda. Judge Cerda was appointed an appellate court judge in 1965. He was very influential in the LULAC organization and was the first Mexican to serve as a judge.

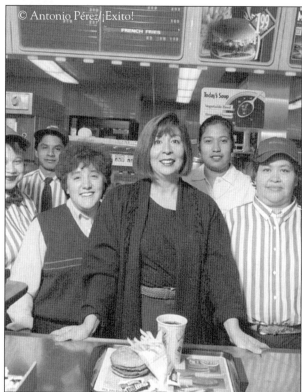

© Antonio Pérez/¡Exito!

Virginia Ojeda is one of Chicago's most successful entrepreneurs. She has also been extremely active on numerous city and community boards. Her mother, Susie Gómez, is pictured on page 23 in her christening outfit.

In recent years, there have been new schools constructed in Mexican neighborhoods throughout Chicago, but issues of educational equity and overcrowded schools remain. Shown here reading with a student is bilingual teacher Sandra Hurtado.

Gery Chico, President of the Chicago Board of Education, has received national attention for leading Chicago's efforts to upgrade the school system. Once described as the nation's worst schools by President Reagan's Secretary of Education William Bennett, today Chicago's efforts are being studied for their innovation. Although the schools have come a long way under Chico's leadership, challenges continue.

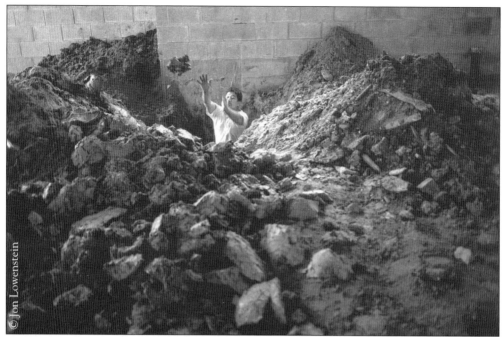

Unfortunately, some things never change. The exploitation of Mexican laborers that began when they first arrived in Chicago continues today for some Mexican day laborers. These individuals, who are usually undocumented, are paid and treated very poorly to do manual labor. Pictured is a Mexican day laborer clearing out an area for a tunnel using only his hands on Chicago's North Side.

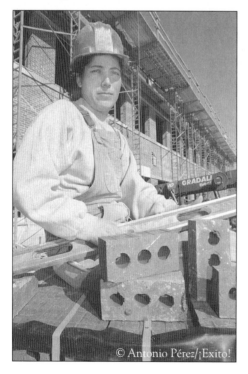

Edelia Liñan is shown here on a Chicago Public School worksite. A union bricklayer, she came to Chicago from Jalisco, Mexico. At the time of this photo, her future plans included taking coursework at the University of Illinois to become an architect.

130

A butcher in a small Mexican food store, stands in front of the meat counter. *Carnicerías* like these provide a place where Mexican customers can order cuts of meat not usually found in American grocery stores.

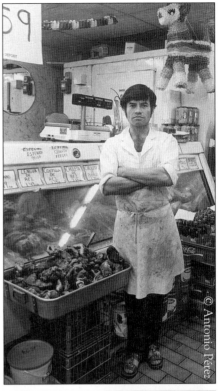

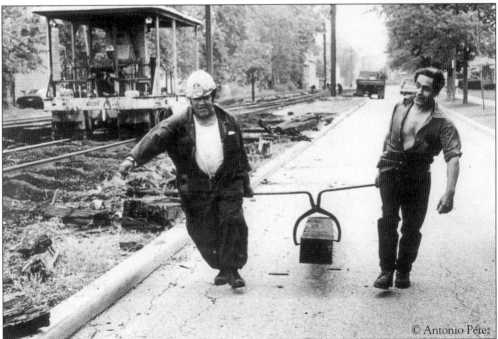

Two Mexican men are captured here carrying a railroad tie while repairing track in South Chicago. The railroads in both Mexico and the United States continue to employ thousands of Mexicans.

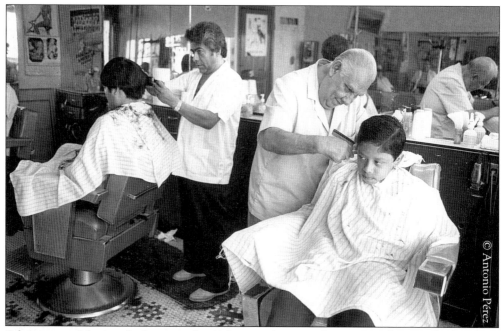

Peluqueros, or Mexican barbers, are shown here working on clients in a *peluquería*, barber shop, in Pilsen.

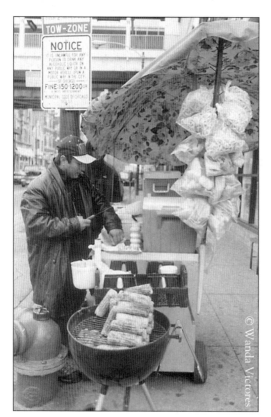

Throughout Mexican neighborhoods in Chicago, vendors with carts like this one sell corn, fresh fruit, *paletas*, or popsicles. There is an ongoing battle about them, putting restaurant owners, city inspectors, and the vendors themselves at odds with each other.

Pictured here is a worker in a *tlachería*, Angel's Tire Shop in Pilsen.

© Wanda Victores

Mary González Koenig has been a vibrant force on numerous issues that impact the Mexican community. In addition to serving in Mayor Richard M. Daley's administration, Koenig is probably best known for her role as the executive director of Spanish Coalition for Jobs. For the past few decades, this organization has trained hundreds of workers for positions at sites throughout Chicago.

This 1990s photograph captures three prominent Chicago Mexicans—Matt Rodríguez, Vince Barba, and Ricardo Muñoz. Rodríguez was the first Mexican appointed Superintendent of the Chicago Police Department. Barba has been active in many Mexican civic and community organizations. Muñoz has served Little Village as alderman for several terms.

© Miguel Zuno

Adela Coronado Greeley has earned universal acclaim for her educational advocacy and support for learning English and Spanish. Coronado was one of the co-founders of the Inter-American Elementary School on the city's North Side. This school has received national attention for its innovative approach to teaching children in a dual language setting.

Six

POLITICAL ACTIVISM

As the Mexican population grew after World War II, especially in the 1950s, Mexican political activity grew. The most important development during this period was the formation of the Mexican-American Democratic Organization of Cook County. The driving force behind this group was Arturo Velásquez Sr. Chicago was and is a Democratic city, and the Mexican leadership believed that the best thing that they could do for their community was to cultivate a working relationship with the city's political power brokers. It became a regular routine every election to see Democratic candidates put on a Mexican sombrero and attend some event organized by Mexicans entitled Amigos for _____. In the 1970s, Irene Hernández was slated by the Democratic machine and won election as the first Mexican to hold countywide office as a Cook County Commissioner. But Mexicans were still being left out of political power. Consequently, by the late '70s, with Mexican numbers now becoming substantial, a new generation of Mexican political leaders such as Rudy Lozano, Juan Velásquez, and Juan Soliz grew impatient with the slow progress being made in giving the Mexican community their fair share. These independent Democrats began to challenge the Democratic machine. In races in the 25th ward (which included Pilsen) and the 22nd ward (which included Little Village), they ran unsuccessfully for aldermanic seats.

The 1983 mayoral race became the watershed moment in Chicago's Mexican political movement. The electricity that was brought to Chicago politics by Harold Washington energized the Mexican community like never before. Although Mexicans were defeated in their bids for aldermanic seats, there was no turning back. The 1983 election also saw the defeat of Committeeman Ray Castro for South Chicago's 7th ward aldermanic seat. Castro, a regular democrat, had earlier become the first Mexican to become a ward committeeman.

Although the murder of Rudy Lozano was a severe setback for Mexican independent democrats, his aide, Jesús "Chuy" García, picked up the mantle. By the time the 1980s had ended, Juan Soliz and Jesús García had been elected to office, and the city's political scene would never be the same again. Mexicans were finally beginning to have political power in the city, and this fact could no longer be ignored. However, the death of Harold Washington in 1987 left a void that the city's independent movement had still not recovered from as the city entered the 21st century.

In the 1990s, Mayor Richard M. Daley consolidated his hold of city hall and also reached out to the Mexican community. Daley named Mexicans to prominent city government positions. He appointed the city's first Mexican police superintendent and fire commissioner. Furthermore, Daley entrusted Gery Chico with the job of President of the School Reform Board of Trustees to oversee major changes in Chicago Public Schools. Before the decade ended, in addition to Pilsen and Little Village, Mexicans were winning other races in other communities. Mexicans were not only winning aldermanic seats but also state representative seats, and Jesus García had become the first Mexican state senator. The majority of these newly elected

Mexican politicians such as Ambrosio Medrano, Danny Soliz, Ray Frias, and Jesse Granato were strongly aligned with Mayor Daley. For Mexican independents, the last few years were a time of reversals. The reelection defeats of Jesús García in 1998 for state senator and the 2000 defeat of Sonia Silva for state representative left Ricardo "Ricky" Muñoz, the Alderman of the 22nd ward, as the only holdover from the Mexican independent democratic movement.

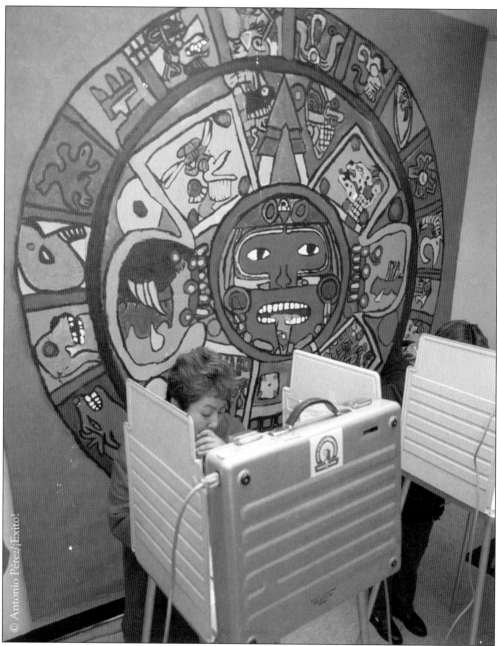

Mexican aspirations for a more equitable society are symbolically captured as this Aztec Calendar seems to be looking over the shoulder of this Mexican voter.

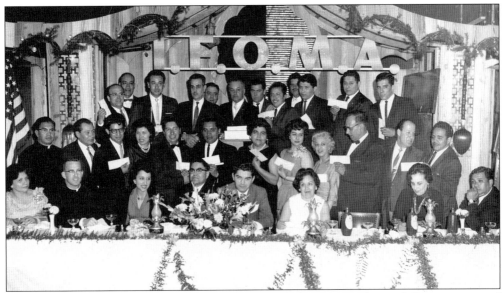

The Illinois Federation of Mexican Americans, founded in 1949 and now defunct, was one of the first serious efforts to organize various leaders in the Mexican community statewide in order to advocate for changes in their community.

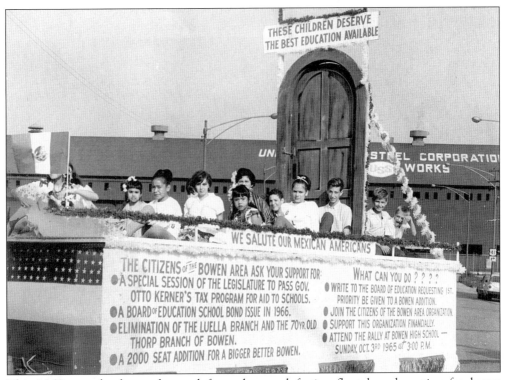

This 1960s parade theme departed from the usual festive float by advocating for better educational facilities for the Mexican community in South Chicago. Bowen High School, cited on the float, was the first Chicago Public High School with a large Mexican population and today still has a large number of Mexican students.

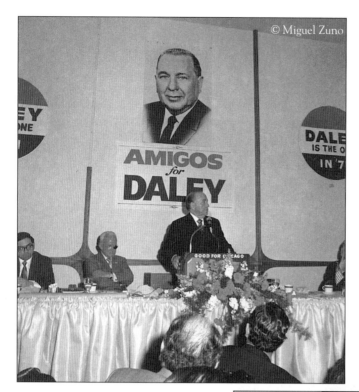

© Miguel Zuno

Mayor Richard J. Daley is pictured speaking at a 1971 rally for Amigos for Daley. Committees such as Amigos for Daley were created in hopes of having candidates remember the importance of the Mexican vote.

© Miguel Zuno

Mayor Jane Byrne's reelection defeat taught a lesson to future Chicago mayors. Candidates had do more than wear sombreros to win the Mexican vote. Real results and not symbolic gestures were necessary for candidates seeking the support of the Mexican community.

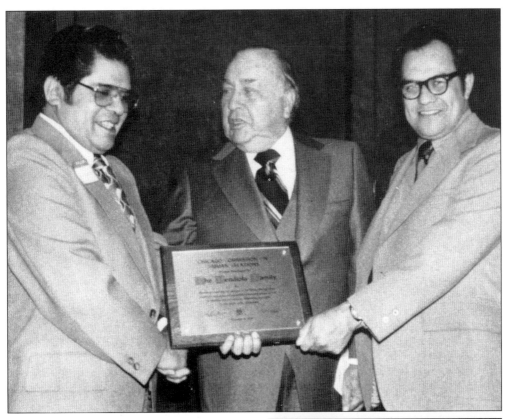

Mayor Richard J. Daley is shown here presenting a Civic and Community Award to Joseph Guadalupe Mendiola and his brother, John J. Mendiola, on behalf of the Chicago Commission on Human Relations. The plaque reads, "To the Mendiola family for leadership by example in the South Chicago community." This presentation done on December 9, 1976, was one of the last official acts done by Mayor Daley the week before his death. The Mendiola family, along with Henry Martínez, were key figures in the Mexican Community Committee of South Chicago.

Ray Castro emerged in the 1970s and the 1980s as the Mexican political leader in the 7th ward in South Chicago. He was the first Mexican elected as a democratic committeeman. His son, Martin, has also become an important citywide leader.

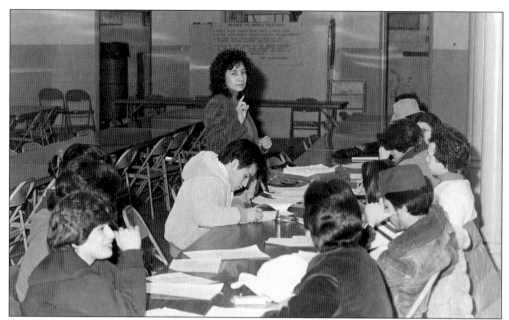

The Mexican-American Legal Defense and Educational Fund (MALDEF) is a national organization with branch office in cities across the United States, including Chicago. MALDEF's successful lawsuit in the early 1980s against a discriminatory ward map was a major victory for the Mexican community. MALDEF executive director, Virginia Martínez, is pictured leading a citizenship class at St. Procopius Church in Pilsen, which was another major MALDEF initiative.

© Antonio Pérez

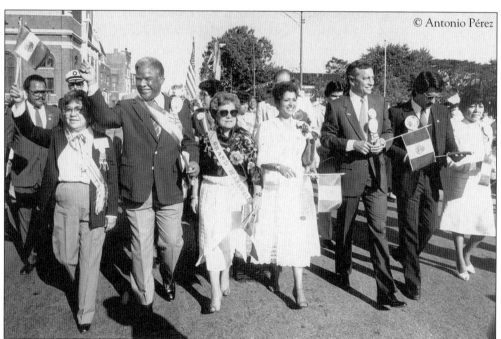

The South Chicago community's 15th of September Parade is being led by important Chicago figures, including Mayor Washington, Parade Marshall Irene Toscano, Edward R. Vrydolyak, Henry Martínez, and members of the Comité Patriótico that organized these yearly events.

In the 1970s, the most prominent Mexican political leader was Irene Hernández. A strong supporter of Mayor Richard J. Daley, Hernández won election as Cook County Commissioner becoming the first Mexican elected to a county position. Her election to county office paved the way for other future Mexican county officials such as Joseph Marío Moreno and Martin Sandoval.

Sonia Silva, pictured at the podium, was the first Mexican woman elected as a state representative. In a triumvirate formed with former state senator Jesús García and current 22nd ward alderman Ricardo Muñoz, they established the Little Village community as the center of the Mexican independent Democratic movement.

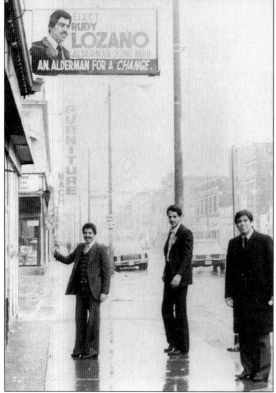

Shaking the hand of Mayor Harold Washington, Rudy Lozano was Washington's key ally in the Mexican community. Lozano's murder shortly after Washington's victory in 1983 was a severe setback for the Chicago Mexican community. Mexicans lost a dynamic, rising political star and their major liaison in the Washington camp.

Rudy Lozano, at the far left, and Juan Soliz, on the far right, are shown entering Lozano's campaign headquarters. After the murder of Lozano, Soliz became the favorite of the Mexican independent movement, winning several elections to different political offices in the 1980s. Soliz later broke with the independent movement and by the early 1990s, he was no longer a factor among Mexican political figures.

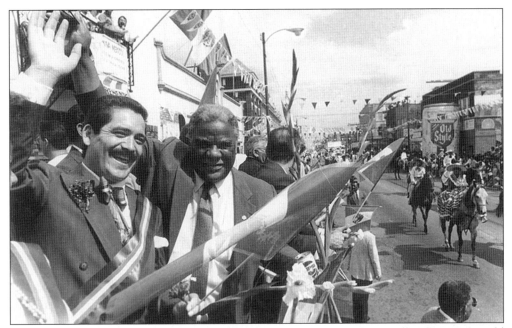

Jesús "Chuy" García was the first Mexican state senator. García, a strong ally of Mayor Harold Washington, is pictured here with the mayor at a Mexican Independence Day Parade. After the murder of Rudy Lozano, García became the leader of the independent Democrats. Chuy is always in the forefront in leading efforts for better schools, housing, transportation needs, economic development, etc., for the Mexican community. In addition, he has taken a deep interest in the political and social issues confronting Mexico, such as fair elections and the struggle for indigenous rights.

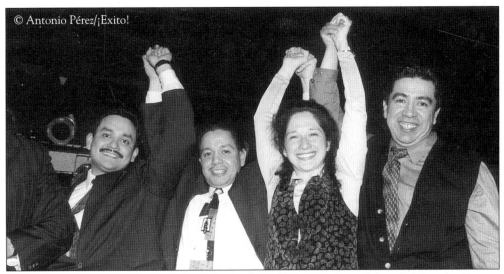

© Antonio Pérez/¡Exito!

Newly elected State Senator Tony Muñoz, State Representative Edward Acevedo, Susana Mendoza, and Alderman Danny Solis celebrate the 1998 victories of Muñoz and Acevedo. Mendoza, who lost by only a handful of votes, would later win election in 2000 against Sonia Silva. This coalition of Mayor Daley allies dealt a severe blow to Mexican independent Democrats by these victories.

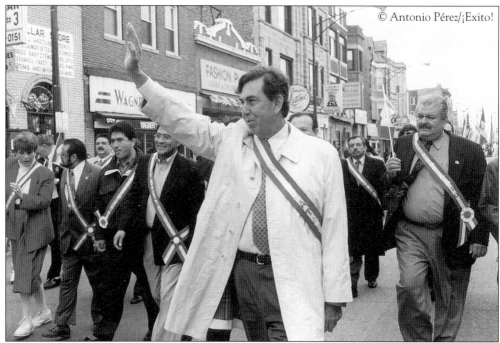

Cuauhtémoc Cárdenas, candidate for the Mexican presidency (1988, 1994, and 2000), is shown here visiting Chicago. He was the first presidential candidate from Mexico to come to Chicago to work intensively at soliciting support from Mexican nationals and sympathizers living here.

In 2000, Raúl Ross Piñeda, pictured on the right, found a loophole in the Mexican laws, which did not rule out Mexican nationals who live abroad from running for Mexico's Chamber of Deputies. With the support of Cuauhtémoc Cárdenas and the PRD party, Ross Pineda became the first person to run as a candidate for Mexico's congress, while living abroad. Although he was not elected, Ross Pineda has paved the way for future Mexican nationals living in the U.S. to run for Mexico's Chamber of Deputies.

Seven

SOCIAL ACTIVISM

From the very beginning of their arrival to Chicago, Mexicans faced intense discrimination. The first phase of social activism began with the union movement. Although not warmly welcomed by the unions, increasing numbers of Mexican workers took an active role in union organizing and participated in union work actions.

Reflecting the social and political activism of the 1960s, the Mexican community began lobbying for improvements in the educational system for better schools and more equitable distribution of resources. Important changes were begun, like the establishment of bilingual programs. The 1977 construction of Benito Juárez High School in Pilsen was an important community victory. Mexican parents and community groups have participated in various school reform attempts, including the most recent reform initiative.

The misguided immigration policies of the federal government over the past 30 years have caused many different Mexican organizations to agitate for change. Beginning gradually in the 1980s, naturalization and voter registration efforts began to increase. In the 1990s, these efforts skyrocketed. Organizations such as UNO (United Neighborhood Organizations), MALDEF (Mexican-American Legal Defense and Educational Fund), NALEO (National Association of Latino Elected Officials), and LULAC (League of United Latin American Citizens) hosted workshops throughout the year to register voters. Juan Andrade, through the Midwest Voters Registration Project and the U.S. Hispanic Leadership Conference, became a leading national figure in this area and was honored by President Clinton with a Presidential Medal for his work.

The beginning and the end of the 20th century were times of significant political change in Mexico. Chicago Mexicans were and are not unaffected by the political events and socio-economic conditions in Mexico. For instance, many Mexicans left Mexico during and after the Mexican Revolution (1910–1917), and many moved to Chicago. Chicago Mexicans have been troubled by the recent socio-political problems in Chiapas. The ties to Mexico held by many Chicago Mexicans also are clearly demonstrated by the millions of dollars sent to family members in Mexico. Dollars sent to Mexico by Mexicans living in the U.S. are the third highest source of dollars for Mexico after tourism and oil.

Chicago Mexicans have been involved in many protest marches and other civil demonstrations, concerning a wide range of issues including immigration, education, and housing concerns. One of the most memorable protests occurred in 1996, after the publication of a column making fun of the Mexican community by Mike Royko, *The Chicago Tribune* columnist. His usual abrasive and satirical style drew the ire of many Mexicans. Some members of the community felt that he had unjustly portrayed Mexicans and as a result, a huge protest march was held in front of the Tribune Tower.

The Women's Movement that swept the nation in the 1960s did not leave Mexican women behind. In addition to the women pictured in this book, there have been many *Mexicanas* who have also assumed leadership positions. Excellent examples of Mexican women leaders include

the following: Pioneer and mentor to many present community activists, Carmen Mendoza started working on community issues at the age of 14 with the Claretians in the 1930s. Her recent death has left a definite void. Mary González has been an extremely successful community organizer and is best known for her work with the Pilsen Neighbors Community Council. Her sister, Teresa MacNamara, has continued Mary's work at Pilsen Neighbors. Both of these women are the daughters of the late community activist Guadalupe Reyes, pictured on page 147. Linda Coronado has worn many hats. She has been a political strategist, was the first chair of the Mayor's Advisory of Latino Affairs under Mayor Washington, and she served as a member of the Chicago Board of Education. Anita Villarreal has been a Mexican leader in Chicago's realty business. Juana Guzmán has developed a national reputation for her arts advocacy.

It is important to note that although political and social concerns impacted Mexicans in the entire city, protests and actions usually were community based. The Mexicans in Pilsen, Little Village, Near West Side, South Chicago, Back of the Yards, etc. would act independently from one another. It has been only in recent years that a more citywide Mexican agenda has been forged.

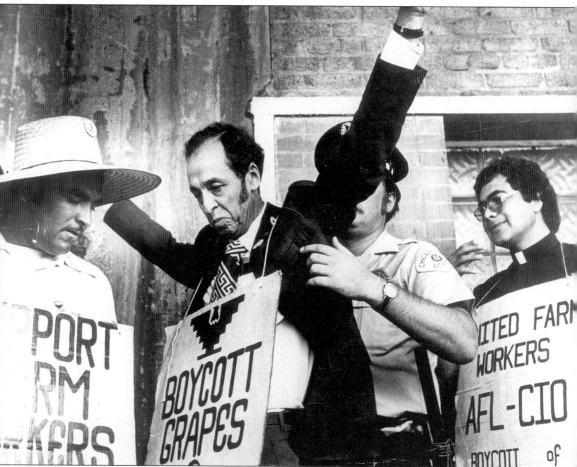

Dr. Jorge Prieto, born in 1918, is shown being arrested for participating in a non-violent protest in support of César Chávez, in the 1960s. The Mexican medical profession and the Mexican community were fortunate to have had Dr. Prieto as a role model and health care advocate. This very gentle and humane man repeatedly demonstrated a passionate commitment to the social issues confronting the Mexican communities during the last half of the 20th century.

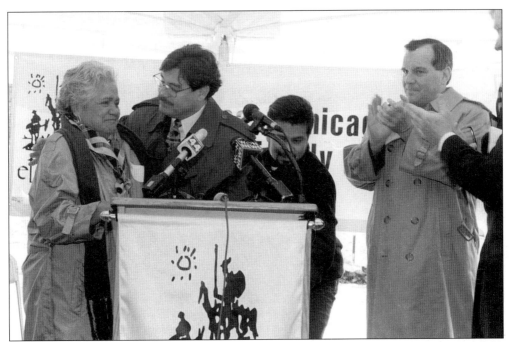

Guadalupe Reyes is pictured with Rey González and Mayor Richard M. Daley at a dedication for El Valor's new building in South Chicago. Guadalupe Reyes epitomized what the word *community activist* symbolizes. Whether the issue was—housing, education, senior citizens, or transportation—Sra. Reyes always advocated for the community. One of her passions was El Valor, a social-service agency that has earned a national reputation for its work with the mentally challenged. El Valor was founded by Reyes and has facilities and programs in Pilsen and in South Chicago. Lupe passed away several months before this book was published. She was and always will be a legend in Chicago's Mexican community.

The opening of Benito Juárez High School in 1977 capped years of protest over inadequate facilities for the Pilsen community. This community victory was a precursor of later struggles for school reform. Today, there are many schools named after Mexican heroes and heroines such as Emiliano Zapata, Sor Juana Inés de la Cruz, Francisco E. Madero, Rosario Castellanos, Lázaro Cárdenas, César Chávez, Rudy Lozano, Irma Ruíz, Manuel Perez Jr., and José Clemente Orozco to name a few.

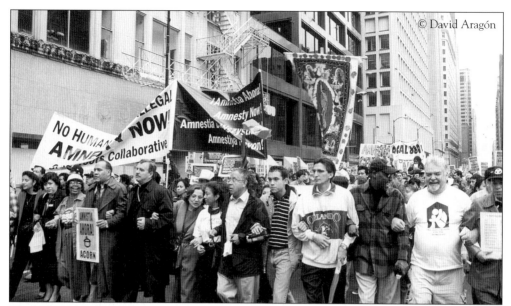

© David Aragón

The rights of undocumented Mexican workers and the struggle for amnesty brought together a coalition of politicians, church leaders, and union leaders to march for justice in September 2000. Despite governmental policies to the contrary, Chicago and the rest of the country increasingly have become more supportive of the rights of the undocumented. Although there is still much anti-immigrant sentiment, there is a growing understanding that Mexican undocumented workers have had a positive impact on the U.S. economy.

© Laura Barrón

The AIDS epidemic has severely impacted the Mexican community. The Mexican community has fought back with the creation of groups such as Proyecto Vida—a Little Village-based organization, which has worked to educate the Mexican community about this disease.

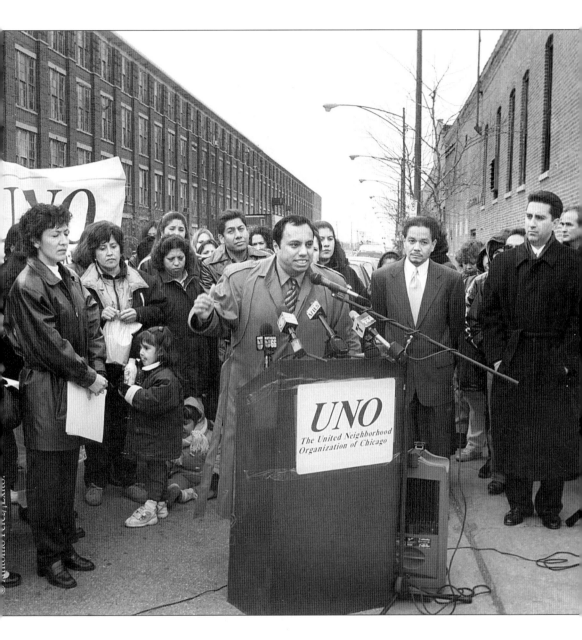

UNO (United Neighborhoods Organization) rose to prominence in the 1980s. This Mexican community organization became a leading voice in issues such as citizenship drives and school reform. Originally headed by present 25th Ward Alderman Danny Solis, it is now led by Juan Rangel (shown speaking in the photo). UNO has become Mayor Richard M. Daley's principal ally among Mexican organizations. On the right side of the photo, Mexican political leaders, State Representative Ed Acevedo and Alderman Ray Frias, are pictured.

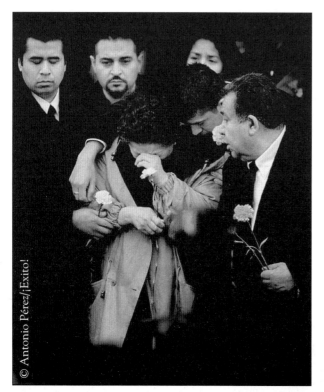

Arnold Mireles' family, pictured here supporting his grieving mother, mourn the murder of this community activist in 1998. Mireles was killed because of his outspoken concerns for improving housing conditions in South Chicago. His death touched an emotional chord throughout the city.

The Resurrection Project has in the last decade become a leading advocacy group in the Mexican community. Based in Pilsen, the Resurrection Project (TRP) is a coalition of Catholic church groups. TRP has earned a great deal of attention for many of their issues, especially housing. TRP's housing initiative has allowed many Mexican families to purchase their first home, such as the one pictured here. TRP executive director, Raúl Raymundo, is on the far right in the photo.

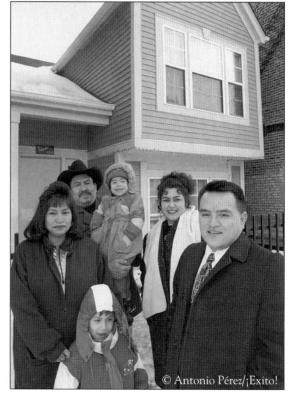

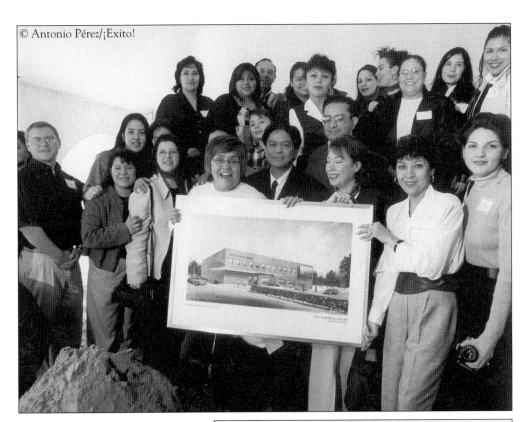

Carmen Velásquez, founder and executive director of the Alivio Medical Center, is pictured first on the left, proudly holding a rendition of their second health center, which opened in 2000. The first center opened over a decade earlier. Both centers are based in Pilsen and have become models on how communities can empower themselves in the health field.

When Cristo Rey High School opened its doors in 1996, it marked the first high school opened by the Archdiocese in a generation. This Jesuit-run school, located in Pilsen, serves an overwhelmingly Mexican student body. The school has been recognized for its many innovations, one of which is that students intern one school day a week to earn money to pay for their tuition.

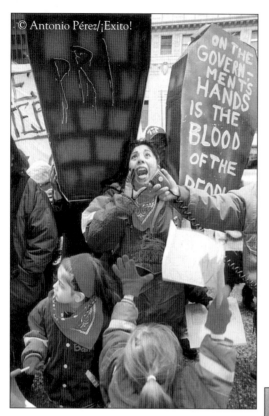

© Antonio Pérez/¡Exito!

The Zapatista uprising in the Mexican state of Chiapas in 1994 brought worldwide condemnation to the mistreatment of Mexico's indigenous peoples. Chicago was no exception, as many individuals from Chicago's Mexican community rallied to show solidarity with the indigenous peoples of Chiapas. Emma Lozano, sister of slain political leader Rudy Lozano, is shown speaking at a rally.

The U.S. Department of Immigration and Naturalization Services has a long track record of abusive and capricious treatment of Mexican immigrants. The Mexican flag and iconic images of the Virgen de Guadalupe and Emiliano Zapata are symbolically used here to rally Mexicans around immigration issues.

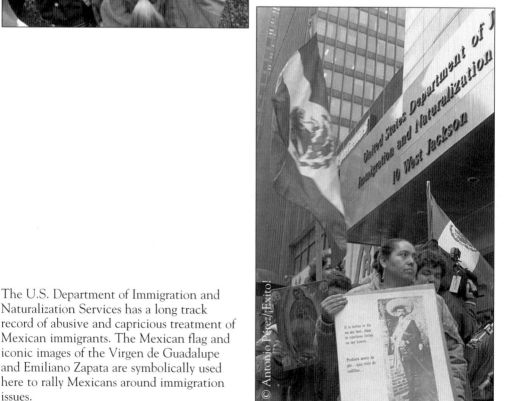

© Antonio Pérez/¡Exito!

152

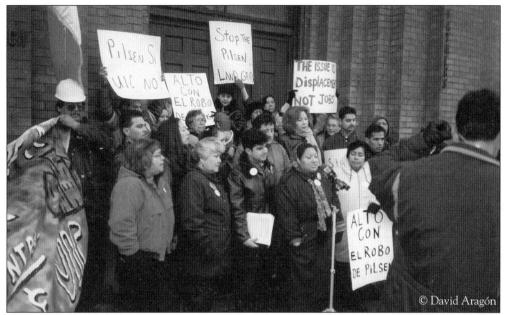

© David Aragón

A very hot and emotional issue for the Pilsen community in the last few years has been the expansion of the University of Illinois at Chicago (UIC). Concerns about the displacement of the Mexican community and the gentrification of Pilsen have galvanized many Pilsen residents and organizations to oppose UIC's expansion. Pictured, from left to right, are: Carmen Velásquez, Teresa Fraga, and Agustin Gómez-Leal in front of St. Francis Church, also called San Francisco, which is now for all practical purposes surrounded by the university.

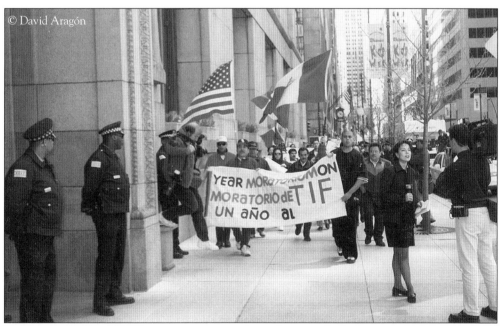

© David Aragón

Tax Increment Fund (TIF) protestors are marching along city hall, protesting the gentrification that continues to pose a threat to Pilsen's Mexican community. The planned creation of a TIF for Pilsen has aroused a great deal of apprehension about the future plans for Pilsen.

153

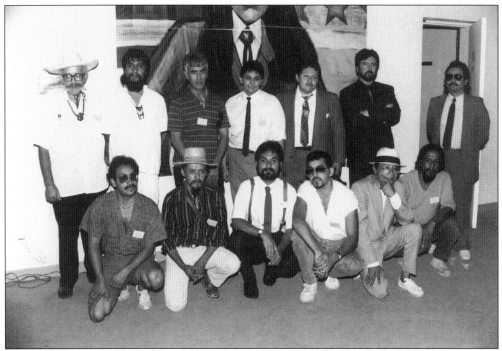

Many of the leading Mexican muralists are shown here at the 1987 exhibition, *Barrio Murals*, at the Mexican Fine Arts Center Museum. Pictured, from left to right, are: Román Villarreal, Hector Duarte, René Arceo (exhibition curator), Roberto Valadez, Marcos Raya, and Benny Ordoñez; (back row) Carlos Córtez, Aurelio Díaz, José Guerrero, Jaime Longoria, Francisco Mendoza, Alejandro Romero, and Carlos "Moth" Barrera.

This movie still from the film, *Israel in Exile*, is an historic first. The film, which premiered in 2001 and was directed by Juan Ramírez of Latino Chicago Theater, marked the first film made by a Chicago Mexican. The film tells the story of two Mexican boxers and how their futures and dreams are tied together.

Eight

ARTS AND CULTURE

Wherever Mexicans settled in Chicago, they brought their artistic heritage with them. As early as the 1920s, Mexican music and dance groups were formed. In the '30s, the Mexican mural movement—which was led by Diego Rivera, David Alfaro Siqueiros, and José Clemente Orozco—was the inspiration behind President Roosevelt's WPA public art program. Murals influenced by the Mexican movement sprang up at public buildings throughout Chicago. In the 1940s and especially by the 1950s, Mexican film and musical stars would make appearances in Chicago. By the '50s and '60s, visits to movie theaters like the San Juan and Senate on the North Side, the Tampico on Roosevelt, and Paulina and the Gayety on Commercial Avenue in South Chicago had become weekly rituals for many Mexican families. These films featured the great stars of Mexico—Cantinflas, Pedro Infante, Jorge Negrete, Tin Tan, and el Santo. In the 1960s, Antonio Aguilar's annual Mexican-style rodeo-*charrería* with music and horses would thrill large Mexican audiences.

Thirty years after the WPA program, in 1968, a young Mexican artist, Mario Castillo, painted an outdoor mural by 18th and Halsted, which jumpstarted the Pilsen Mexican Mural Movement. This movement not only inspired artists from throughout Chicago, but also the work of these Mexican muralists was documented in books published in different languages throughout the world. People have come from around the world to see these murals. Other significant artists who participated in Pilsen's Mural Renaissance were Marcos Raya, Salvador Vega, Ray Patlán, Aurelio Díaz, and José Guerrero to name a few. Casa Aztlan, a community service center on 19th Street and Racine became the center of this muralist movement. In the late 1970s and early '80s, arts activist José González promoted local Mexican artists through two groups that he led—MARCH (Movimiento Artístico Chicano) and MiArte.

In 1987, the Mexican Fine Arts Center Museum opened its doors. Bowen High School history teacher Carlos Tortolero and a group consisting mainly of educators founded the museum in 1982. The museum is the nation's largest leading Latino arts organization and is the only Latino museum accredited by the American Association of Museums. In the 1980s and '90s, Juan Ramírez was the mainstay of Latino Chicago Theater. In the 1990s, Chicago natives Ana Castillo and Sandra Cisneros both saw their work receive critical acclaim. Luis Rodríguez, originally from Los Angeles, moved to Chicago and earned national attention with his novel *Always Running*. The '90s also saw the formation of a group specializing in a type of music popular in Mexico known as *son*. Sones de México soon gained a loyal following throughout the city. Chicago is also home to Carlos Córtez, Chicago's legendary artist and poet. Córtez is often referred by many as Chicago's Posada after the great Mexican printmaker José Guadalupe Posada. Córtez's prints have been exhibited at museums around the world. Throughout the 20th century, Mexican intellectuals have visited Chicago. José Vasconcelos, the great Mexican philosopher, taught at the University of Chicago in the early 1930s, after leaving the political turmoil in Mexico. Writers such as Octavio Paz, Carlos Fuentes, Carlos Monsiváis, and Elena Poniatowska have lectured in Chicago.

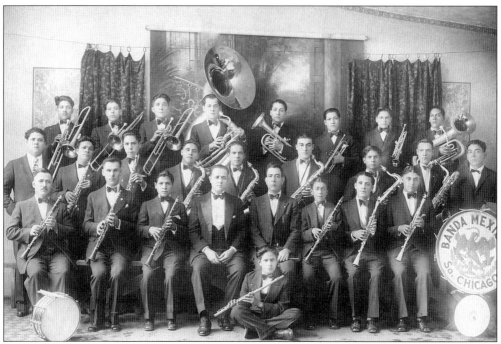

This 1926 photograph is of the Banda Mexicana of South Chicago. This concert band was formed by Cirilio López, shown here fifth from the left in the first row. Mr. López fled religious persecution in Mexico during *La Guerra Cristera*. Also included in the photograph is Felipe J. Castañeda, seated second from the right in the second row. Many of the men in the photograph still have families living in and around Chicago.

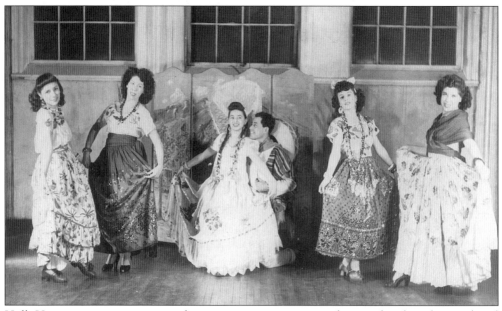

Hull House programs encouraged young immigrants to explore and value their cultural traditions. Shown here is a group of Mexican folkloric dancers from the late 1920s. (Photo courtesy of the University of Illinois at Chicago.)

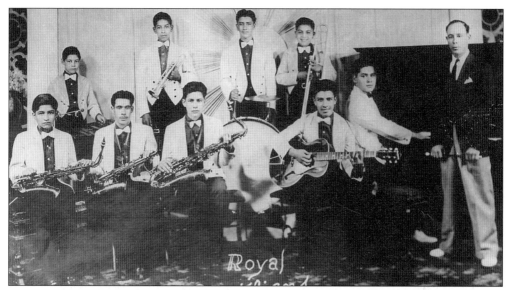

The Royal Castilians, pictured here c. 1928, continued to keep alive the traditional Mexican love of music. As an orchestra they had an extensive repertoire that included classical and popular music. Although the Mexican community was still very small in the 1920s, there was a very apparent need to keep cultural ties strong. Music was a prime vehicle for this cultural statement. At the same time, Chicago's Mexican community also enjoyed the various musical styles that were in vogue in the United States.

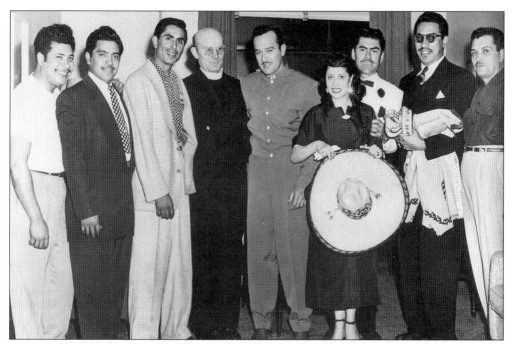

Pedro Infante, one of Mexico's legendary screen and music idols, is pictured in the middle with his arm around Father McPolin, a Claretian missionary, during a visit to Chicago. As the Mexican community grew after World War II, Infante was one of many Mexican stars who came to Chicago to meet his adoring public with the help of entertainment promoters such as Alejo Silva Díaz.

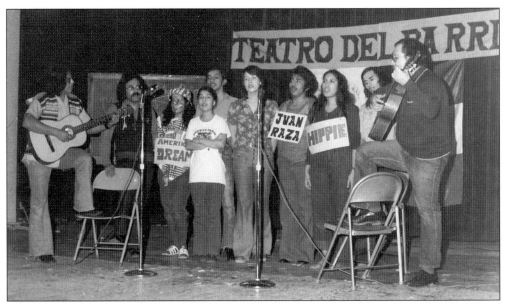

Growing out of the Chicano movement and the social protest movements of the late 1960s and early '70s, through their music and theater, Teatro del Barrio satirically portrayed concerns of the Mexican community.

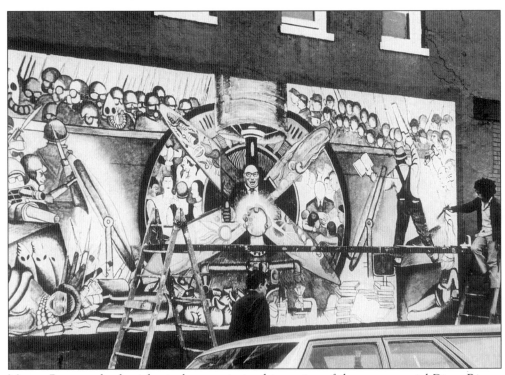

Marcos Raya, at the far right, is shown painting his version of the controversial Diego Rivera mural that was destroyed in New York City's Rockefeller Center. Raya's work has been featured at museums across the United States and in Mexico. Ironically, this important tribute to Rivera was later whitewashed.

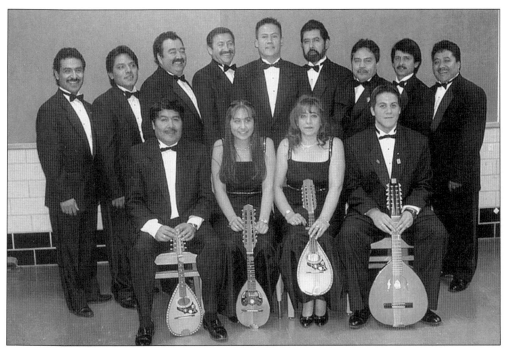

Rodolfo Hernández (seated first in the front row) founded the musical group Cuerdas Clásicas. The group has developed a very loyal following and has performed traditional Mexican music with different stringed instruments throughout the city.

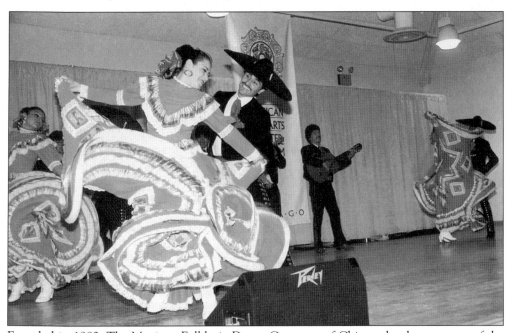

Founded in 1982, The Mexican Folkloric Dance Company of Chicago has become one of the nation's leading folkloric dance groups. Under the artistic leadership of José Ovalle and the administrative stewardship of Henry Roa, the group has performed throughout the Midwest. This photo was taken at a reception held at the Mexican Fine Arts Center Museum in 1990.

159

THE FUTURE

Chicago's Mexican community entered the 21st century with a tremendous amount of excitement. Mexicans have made great strides over the past several decades especially in the 90s. Undoubtedly, there exists a great deal of anticipation within the Mexican community, that the best is yet to come.

According to the U.S. 2000 Census, there are approximately 1.4 million Latinos in the Chicagoland area. With Mexicans comprising an estimated 70 percent of the Latino population, there are close to one million Mexicans living in the area. Two signficant characteristics of Mexican community are that it is growing at a very fast rate and it is a young community. Twenty-five percent of all children in Chicago Public schools are Mexican and this percentage is increasing at a rate of a little over one full percentage point a year. Sometime before the U.S. 2010 Census, Mexicans will become the largest cultural group in the city of Chicago. Due to its substantial population and its ever-increasing presence, the Mexican community of Chicago has assured its growing participation in all areas of society, thus securing better representation in the future.

© Sandra Hurtado

The future of the Mexican community attentively listen to their teacher at the Lázaro Cárdenas School in Little Village.